Midnight Madness
Coloring Book Volume I
Brought To Life By YOU!
The Creative Colorist

Enjoy reversed coloring as you go from coloring inside the lines to actually Coloring the line itself.
Enjoy this book series by artist
CherylColors.

Enter the midnight dark pages and follow the mandala path for a colorful adventure and discover your true colors then come join me on social media in the groups:
Coloring City
&
Coloring With Cheryl Colors

#CherylColorsArt

Collector Book Check List

Doodle Fun Mandala Coloring Books By Cheryl Colors
() Volume 1
() Volume 2
() Volume 3
() Volume 4
() Volume 5
() Volume 6
() Volume 7

Mandala Fun Adult Coloring Books By Cheryl Colors
() Volume 1
() Volume 2
() Volume 3
() Volume 4
() Volume 5

Midnight Mandala Fun Adult Coloring Books By Cheryl Colors
() Volume 1
() Volume 2
() Volume 3
() Volume 4

Midnight Madness Coloring Books By Cheryl Colors
() Volume 1
() Volume 2
() Volume 3
() Volume 4
() Volume 5
() Volume 6
() Volume 7

Join and Share your colored pages in the social media groups
Coloring City
&
Coloring with CherylColors

#CherylColorsArt

Remove this blotter page and use it behind your coloring pages to prevent ink bleed through from markers and gel pens.

This Book Belongs To:

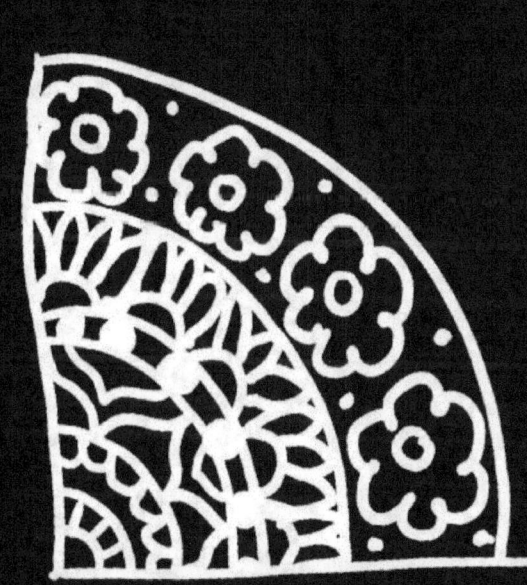
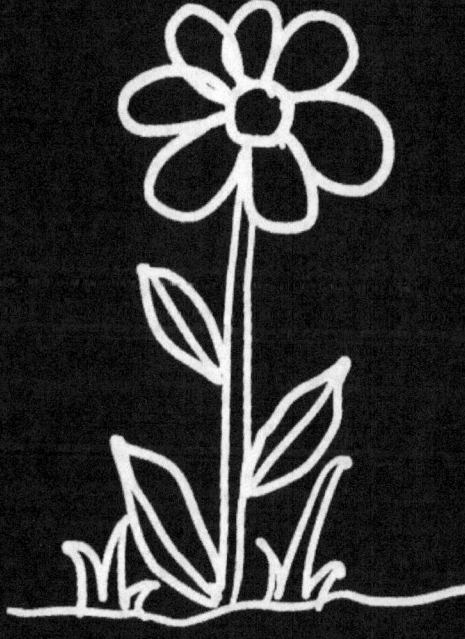

Midnight Madness Coloring Book Volume 1

Join and Share your colored pages in the social media groups

Coloring City

&

Coloring with CherylColors

#CherylColorsArt

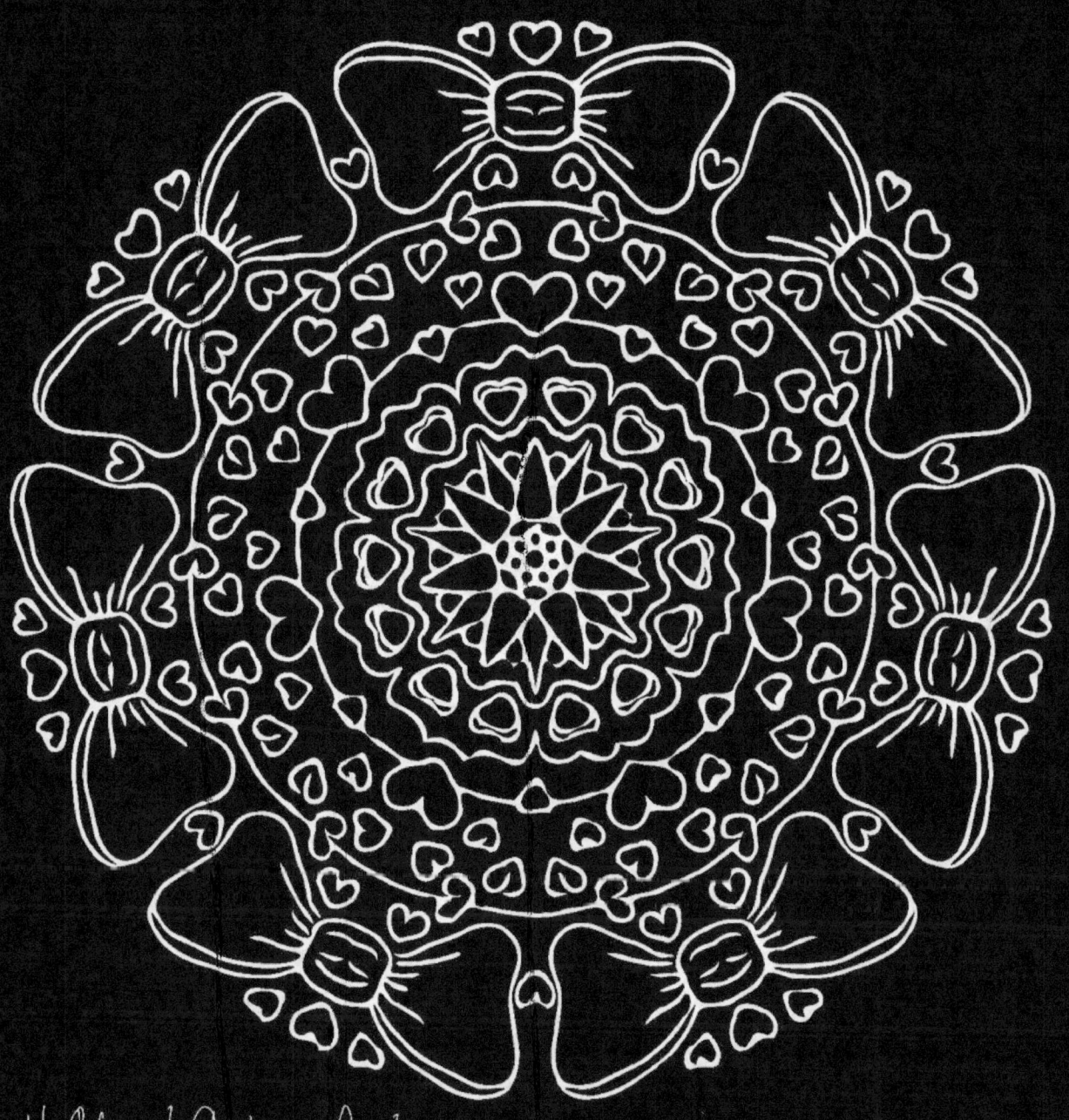

Join and Share your colored pages in the social media groups

Coloring City

&

Coloring with CherylColors

#CherylColorsArt

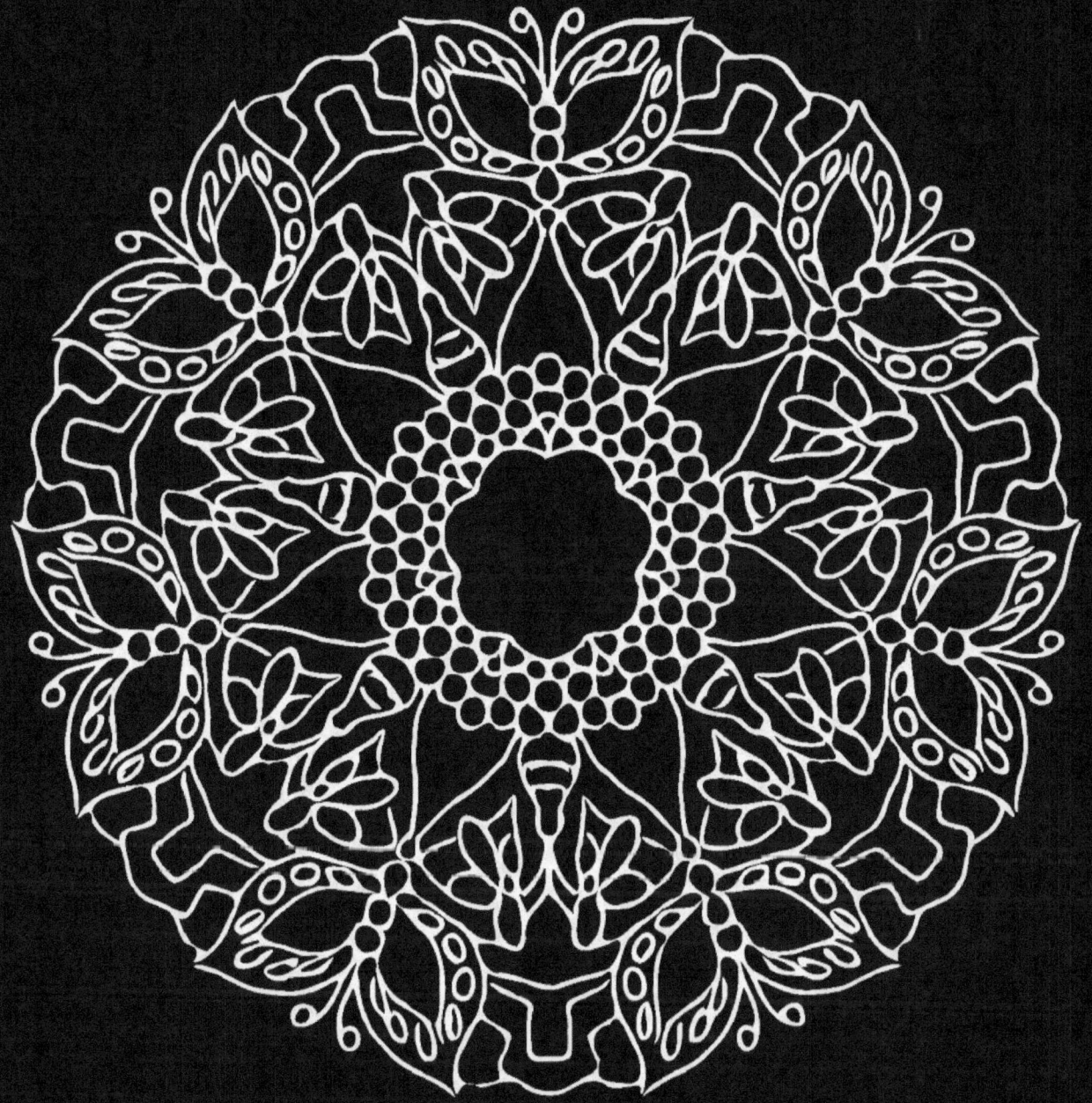

Join and Share your colored pages in the social media groups
Coloring City
&
Coloring with CherylColors

#CherylColorsArt

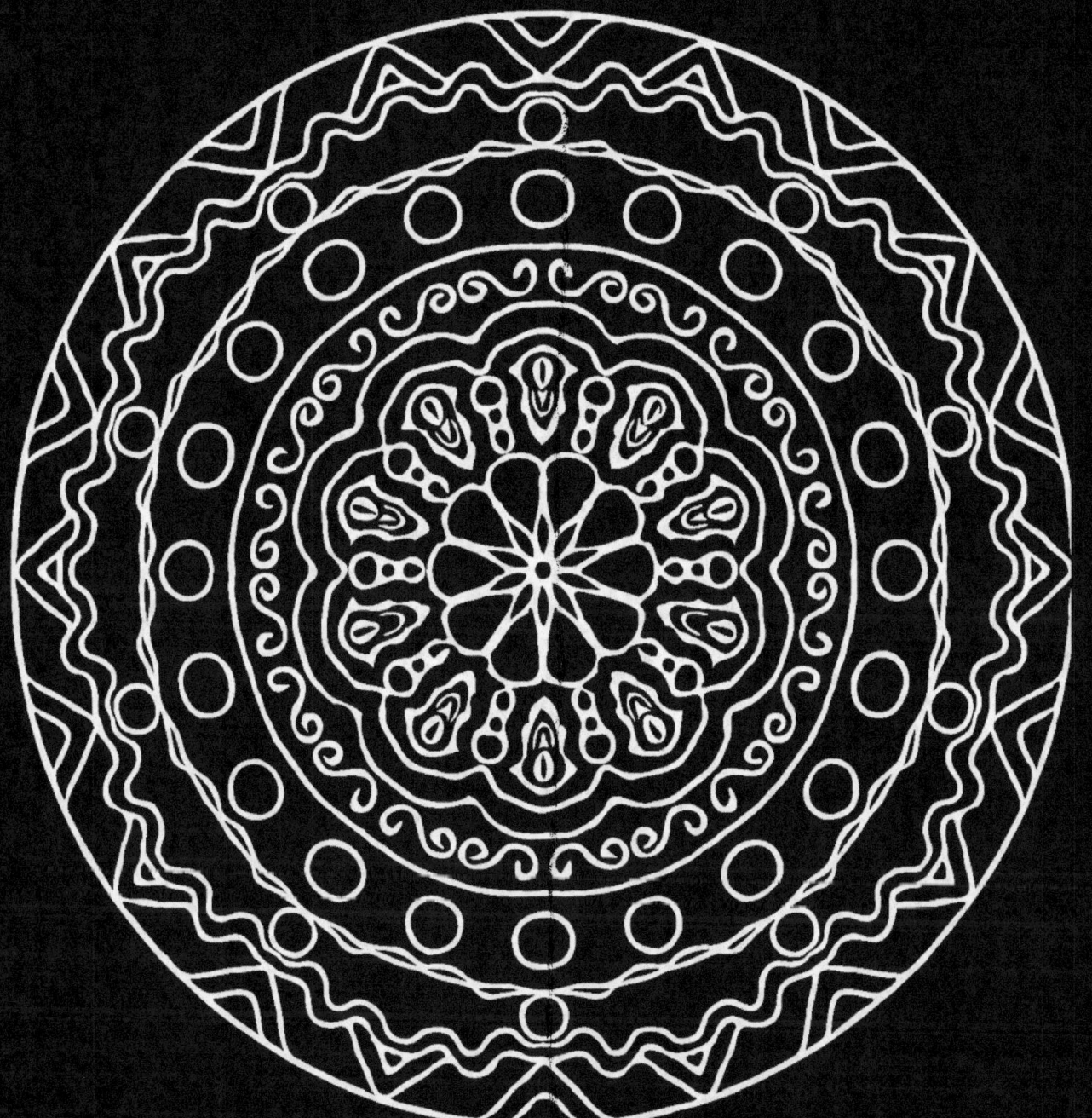

Join and Share your colored pages in the social media groups

Coloring City

&

Coloring with CherylColors

#CherylColorsArt

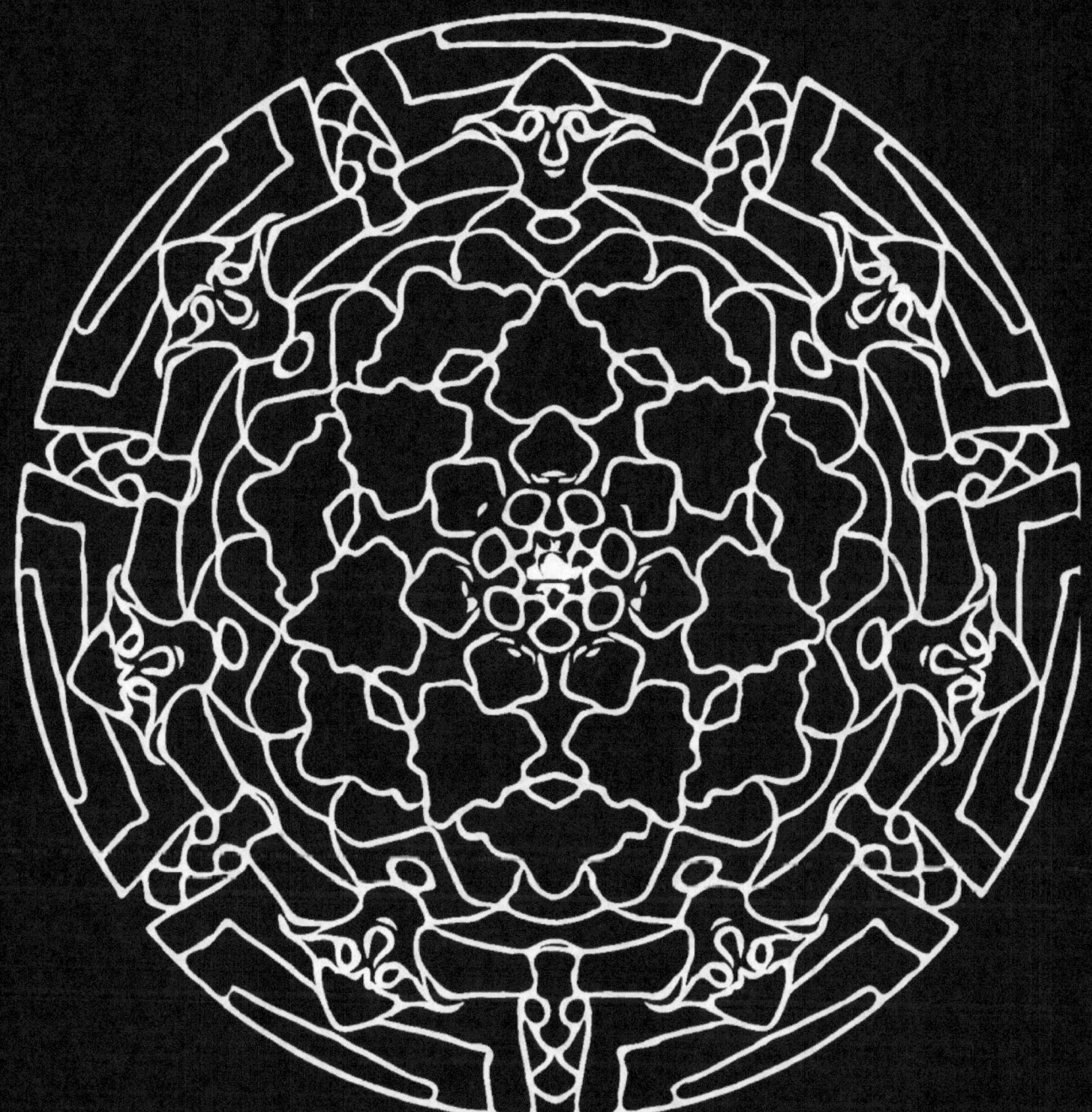

Join and Share your colored pages in the social media groups

Coloring City

&

Coloring with CherylColors

#CherylColorsArt

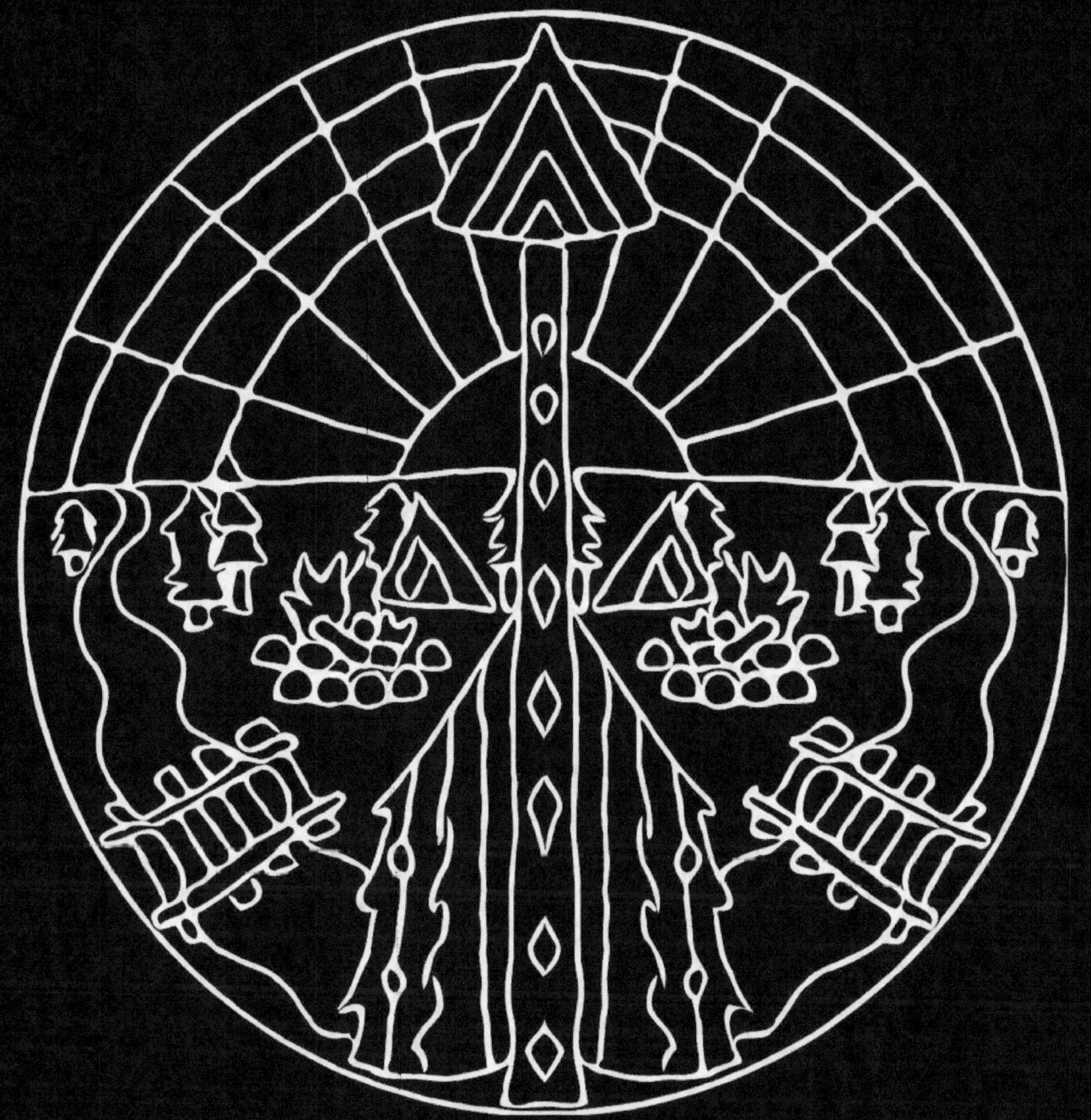

Join and Share your colored pages in the social media groups
Coloring City
&
Coloring with CherylColors

#CherylColorsArt

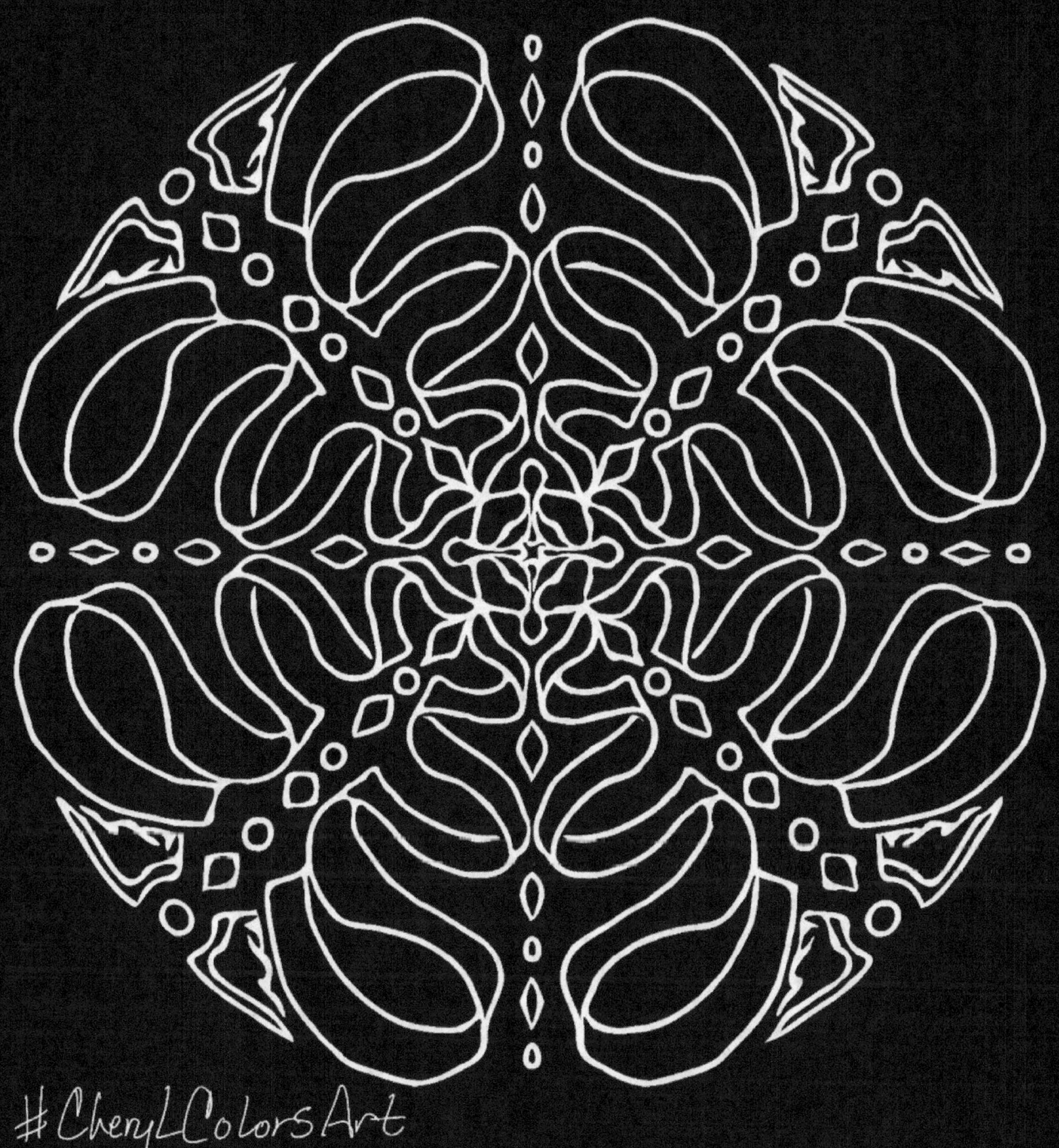

Join and Share your colored pages in the social media groups

Coloring City

&

Coloring with CherylColors

#CherylColorsArt

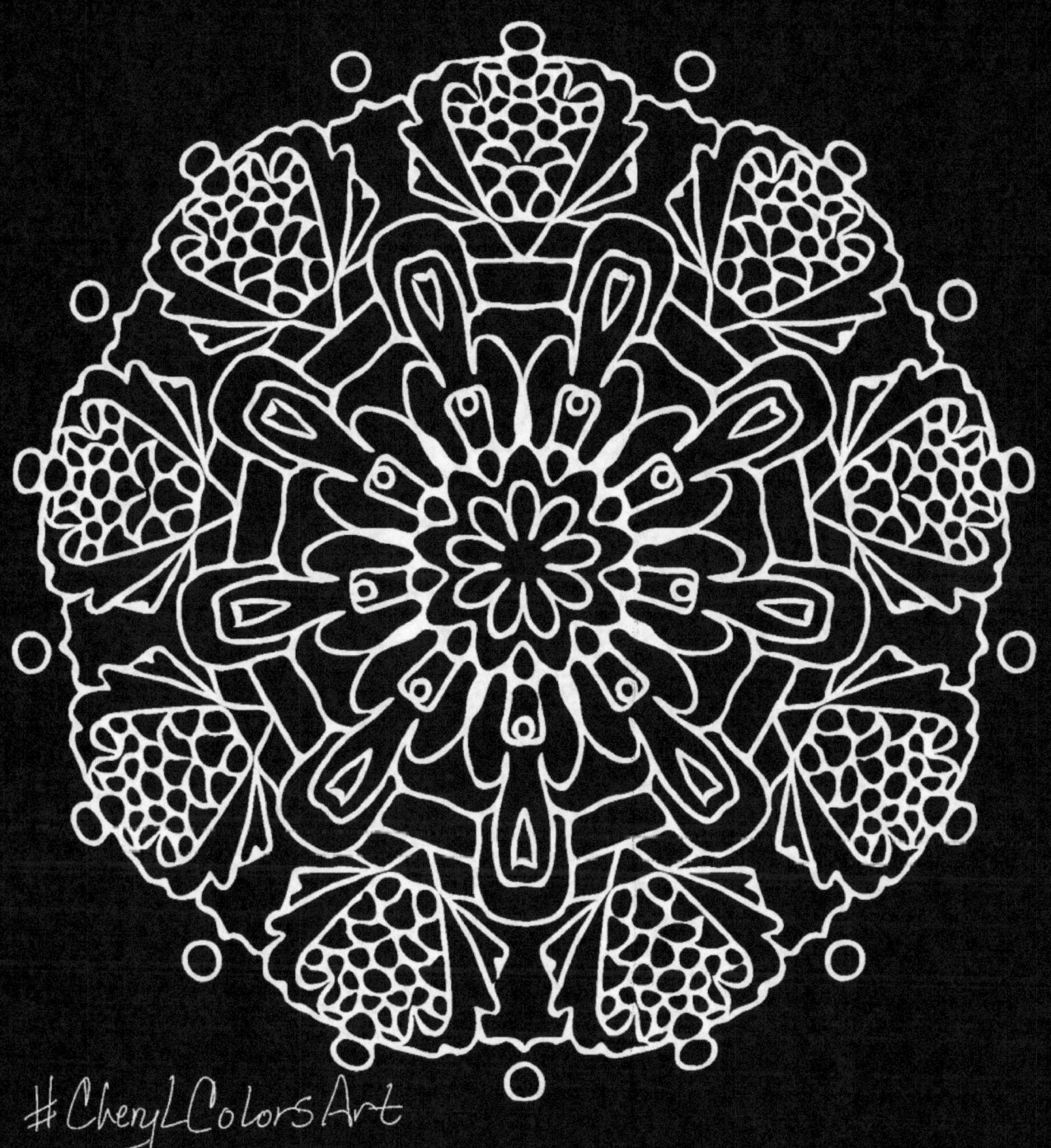

Join and Share your colored pages in the social media groups

Coloring City

&

Coloring with CherylColors

#CherylColorsArt

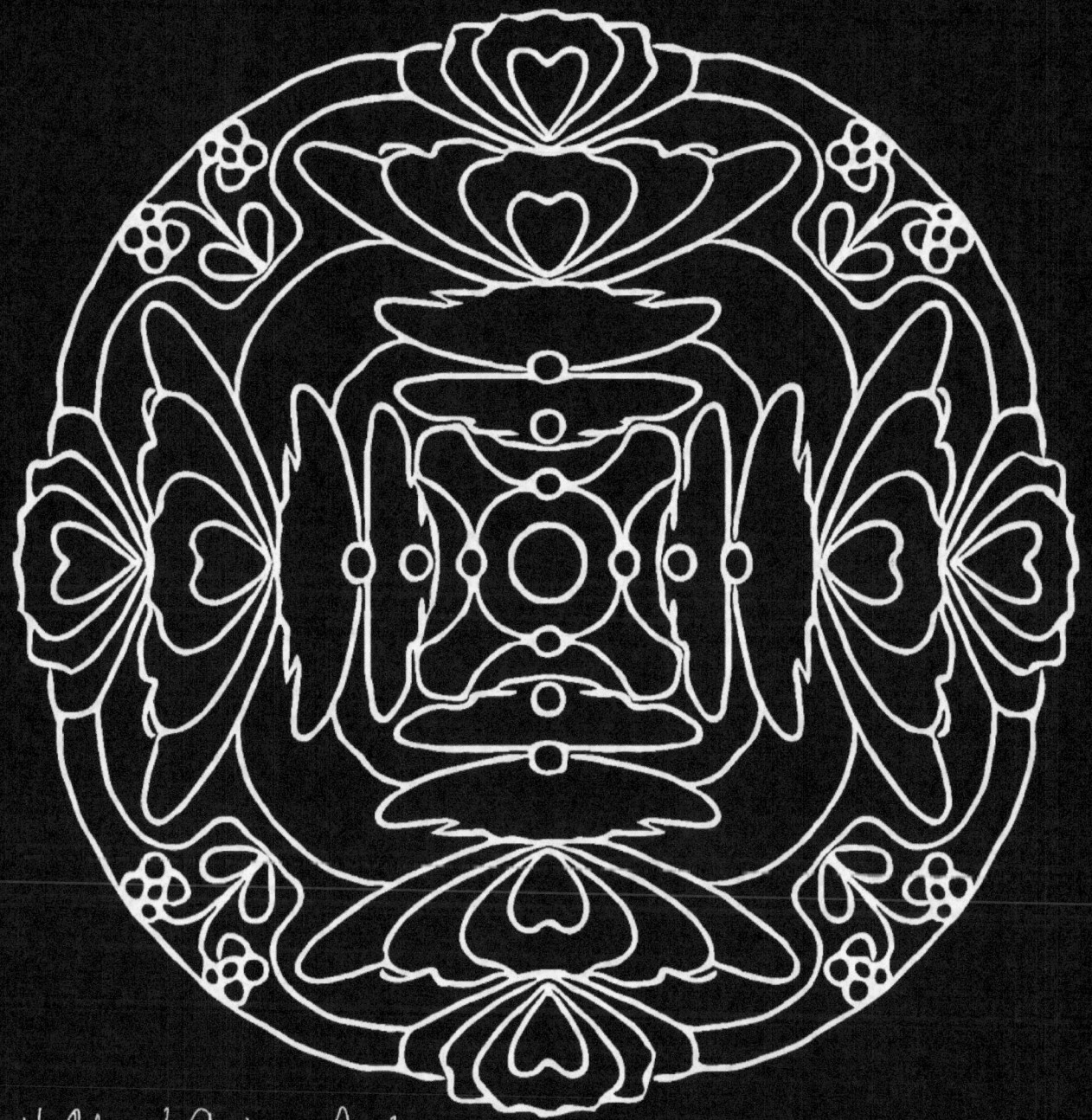

Join and Share your colored pages in the social media groups
Coloring City
&
Coloring with CherylColors

#CherylColorsArt

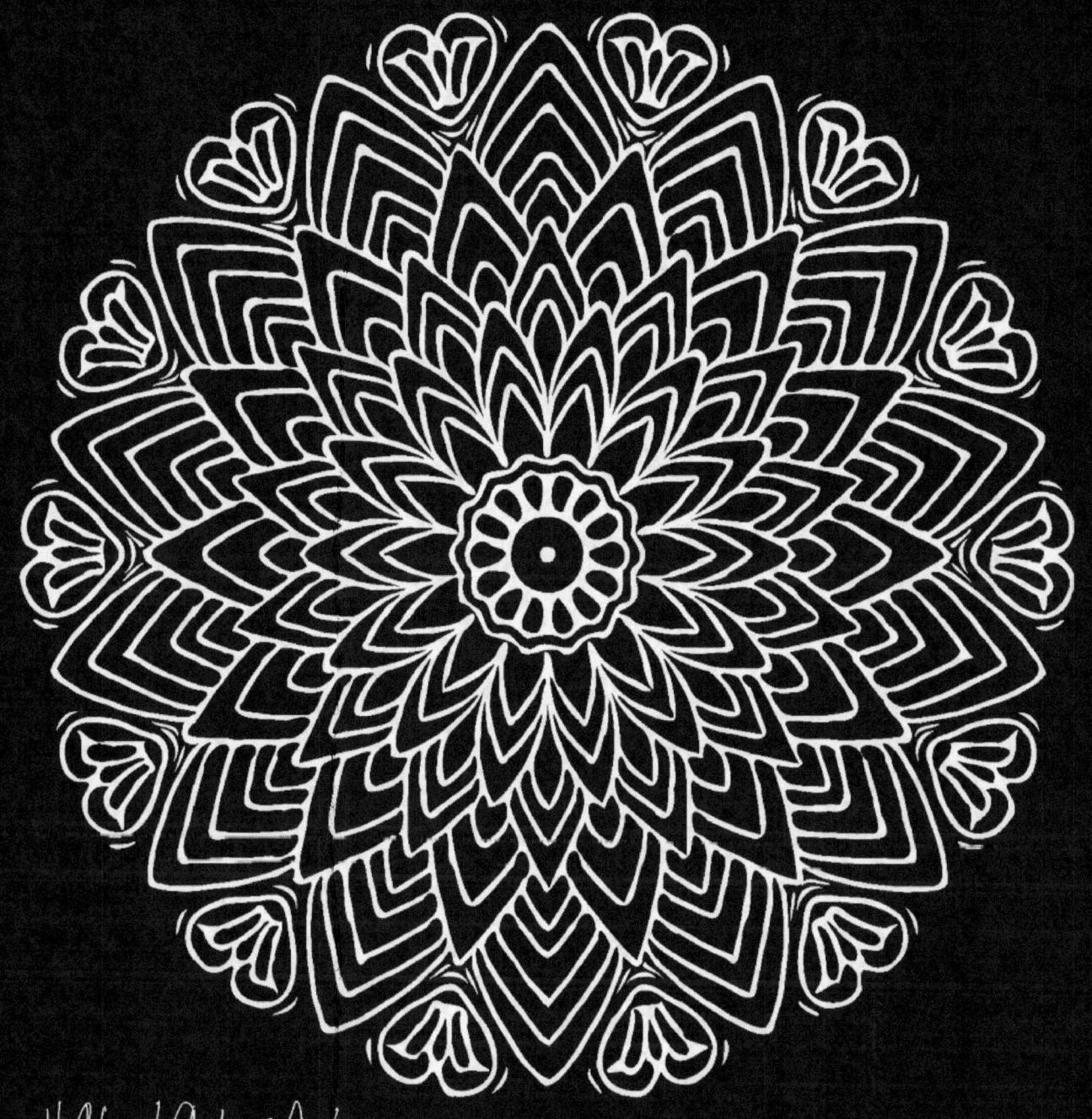

Join and Share your colored pages in the social media groups

Coloring City

&

Coloring with CherylColors

#CherylColorsArt

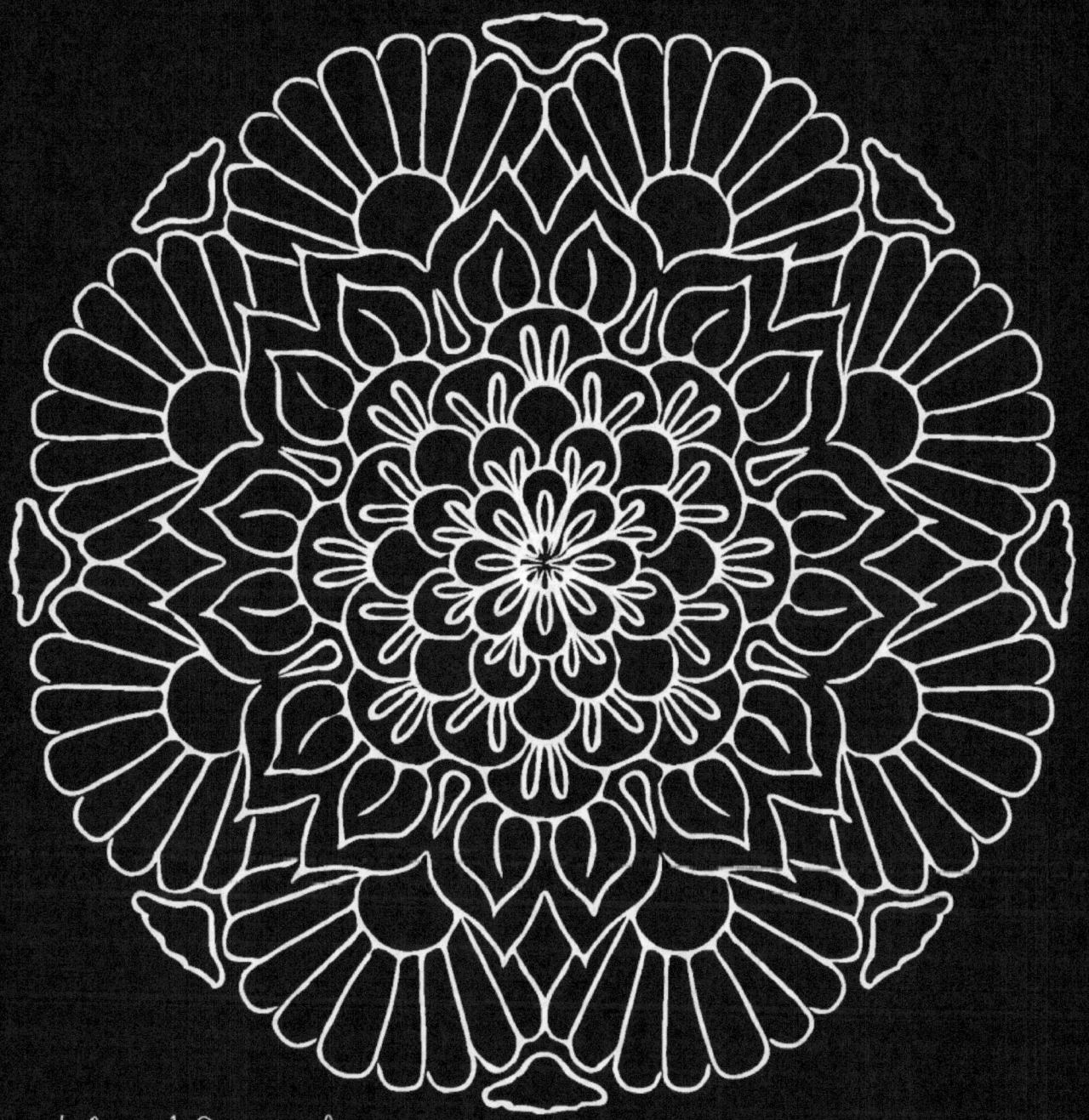

Join and Share your colored pages in the social media groups

Coloring City

&

Coloring with CherylColors

#CherylColorsArt

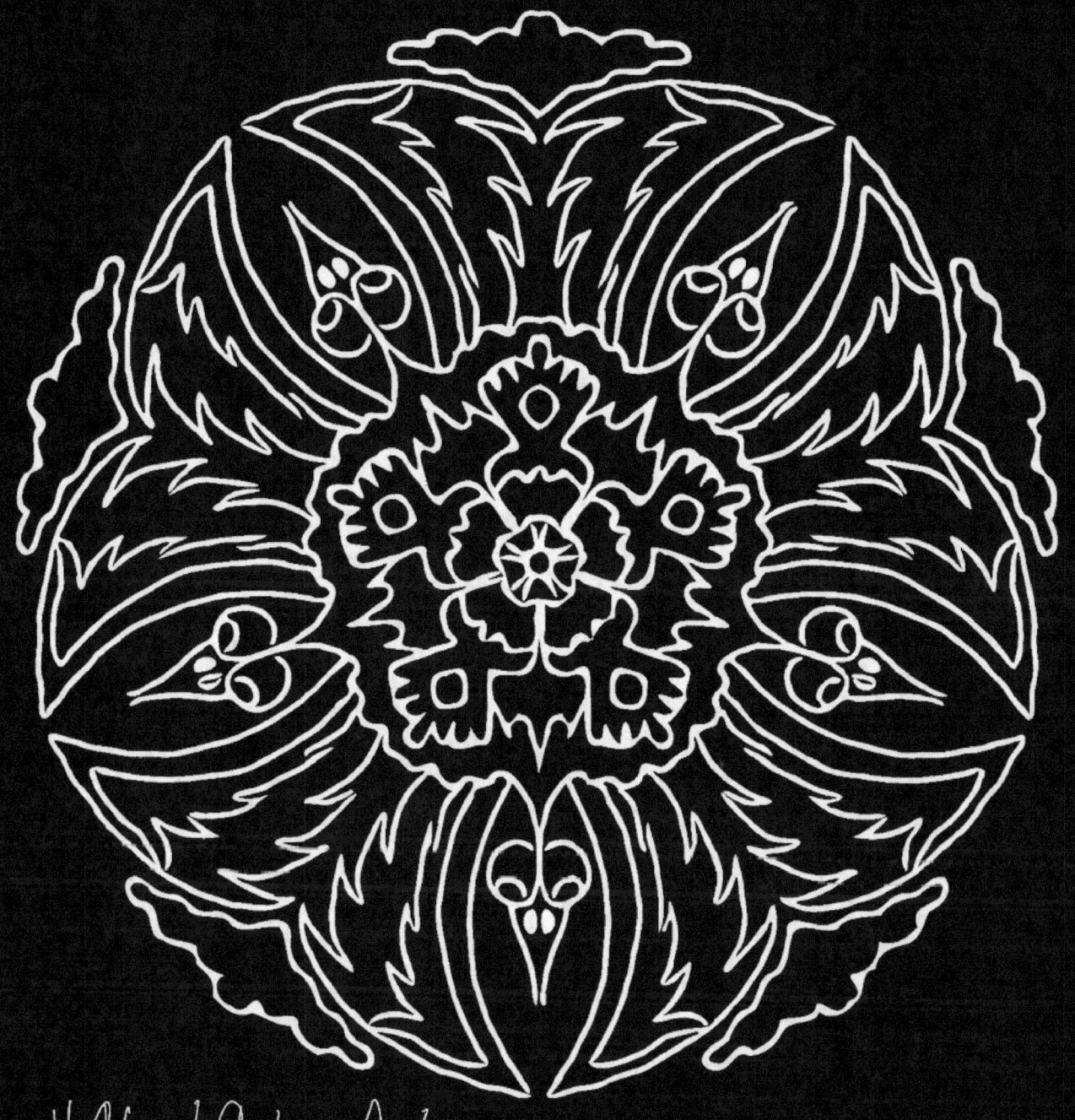

Join and Share your colored pages in the social media groups

Coloring City

&

Coloring with CherylColors

#CherylColorsArt

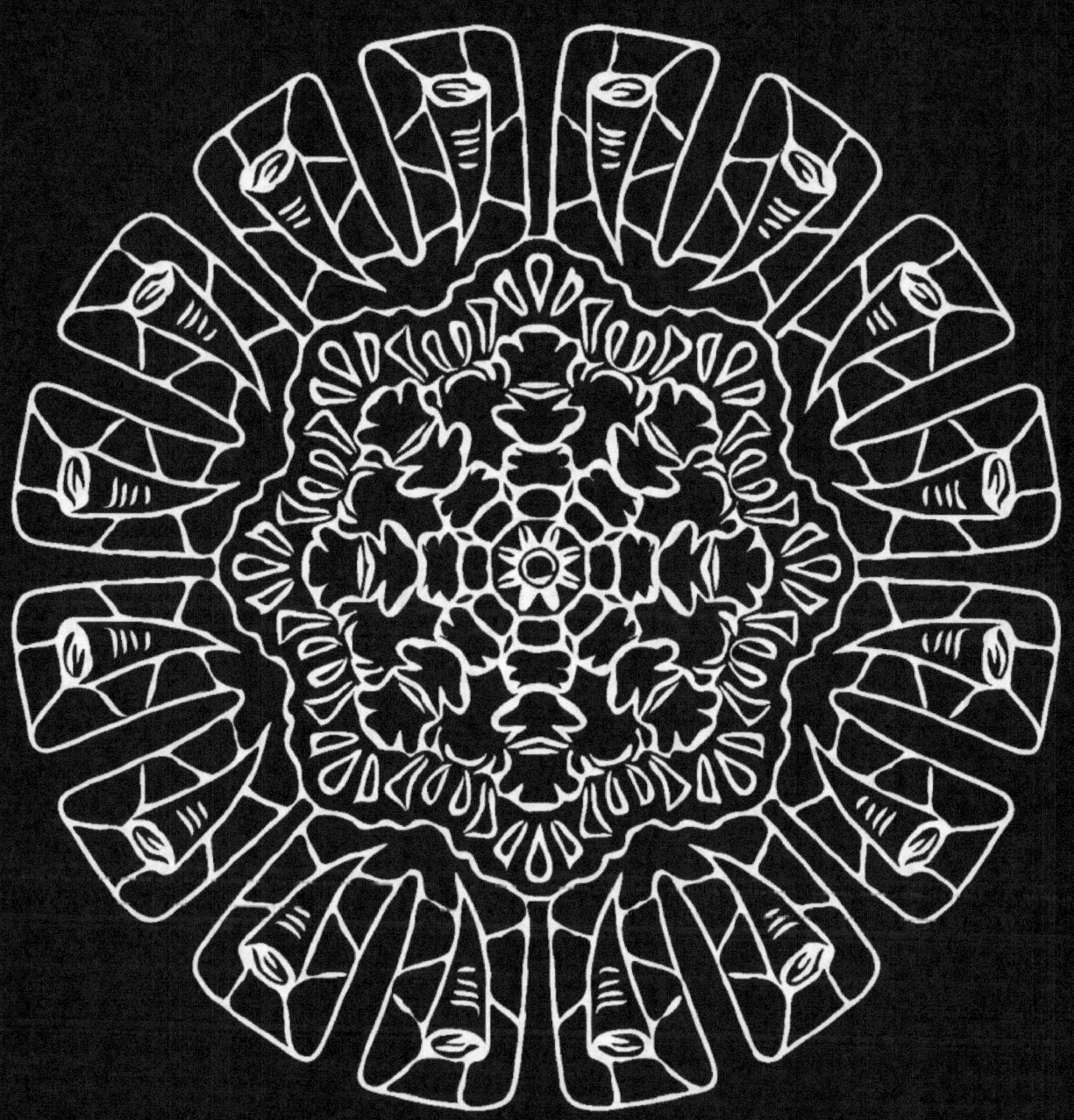

Join and Share your colored pages in the social media groups
Coloring City
&
Coloring with CherylColors

#CherylColorsArt

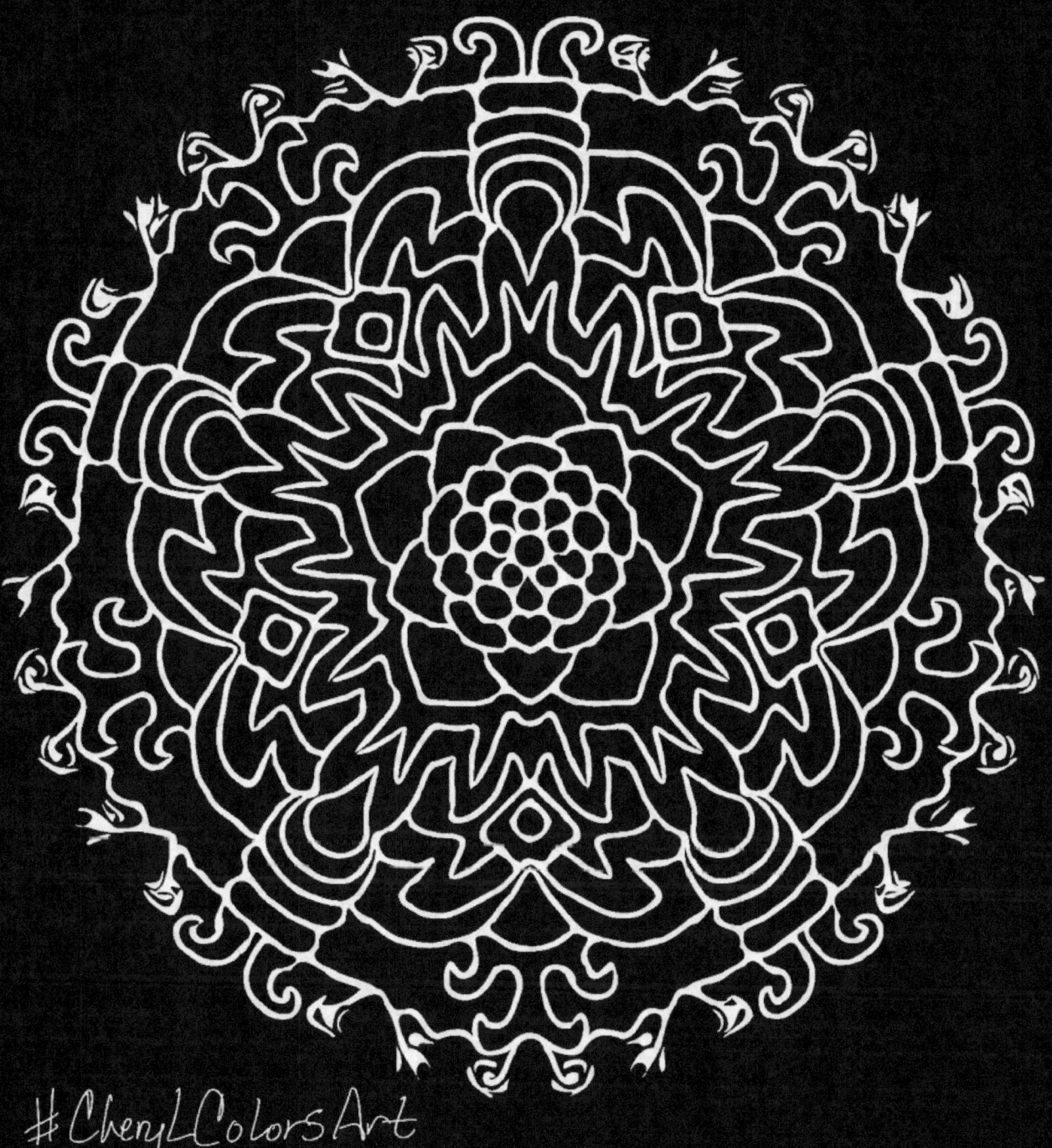

Join and Share your colored pages in the social media groups

Coloring City

&

Coloring with CherylColors

#CherylColorsArt

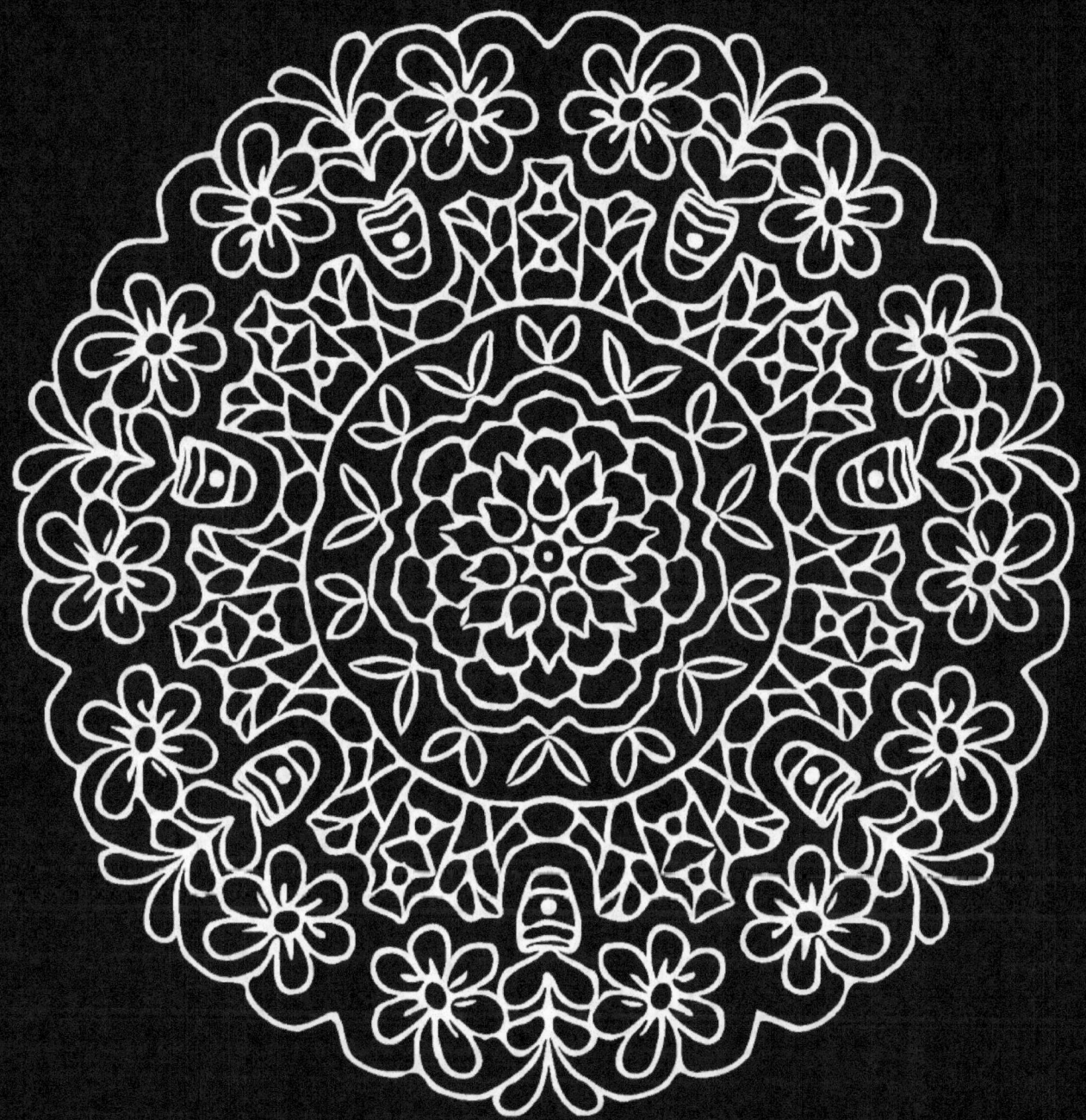

Join and Share your colored pages in the social media groups

Coloring City

&

Coloring with CherylColors

#CherylColorsArt

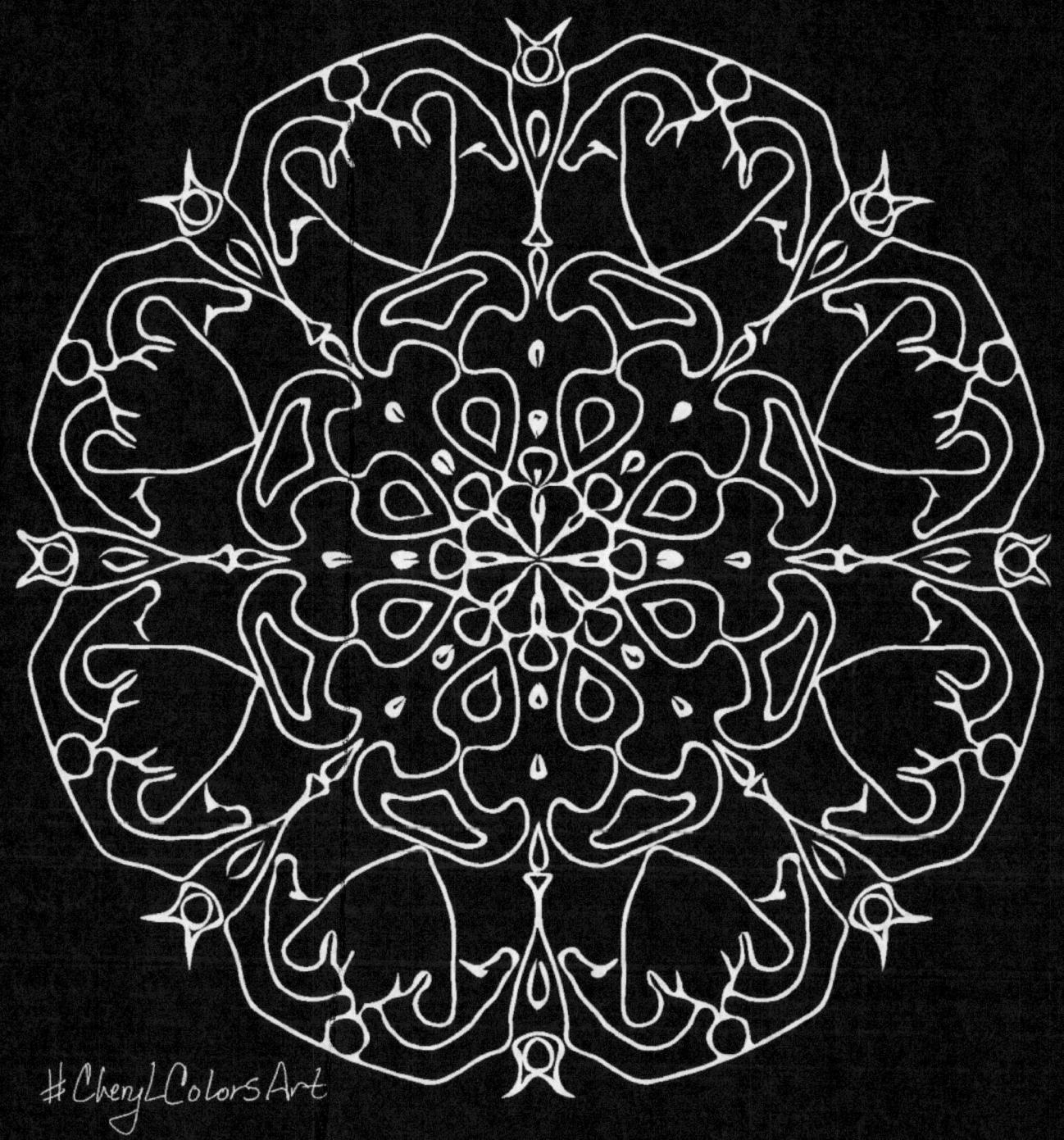

Join and Share your colored pages in the social media groups
Coloring City
&
Coloring with CherylColors

#CherylColorsArt

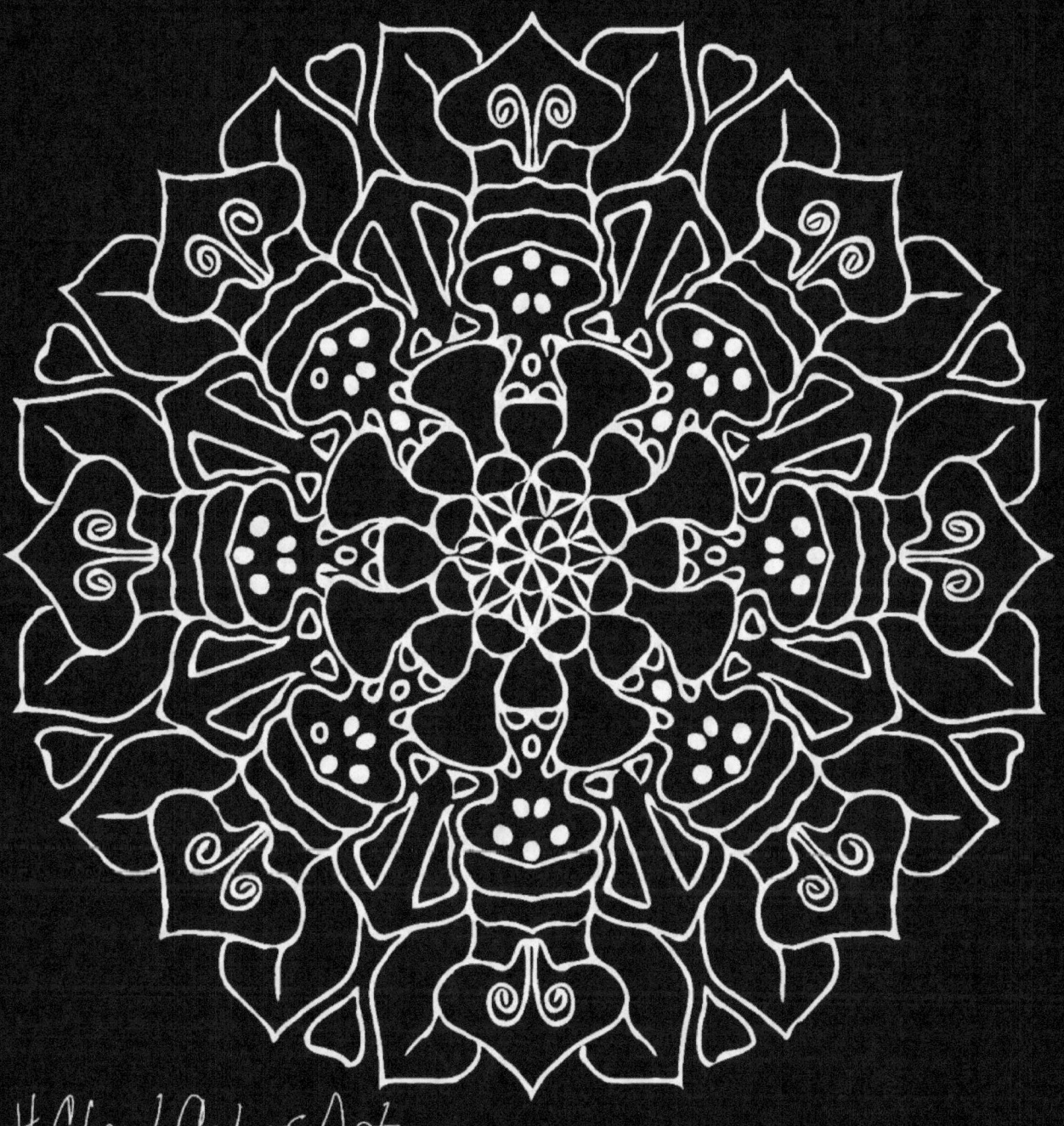

Join and Share your colored pages in the social media groups
Coloring City
&
Coloring with CherylColors

#CherylColorsArt

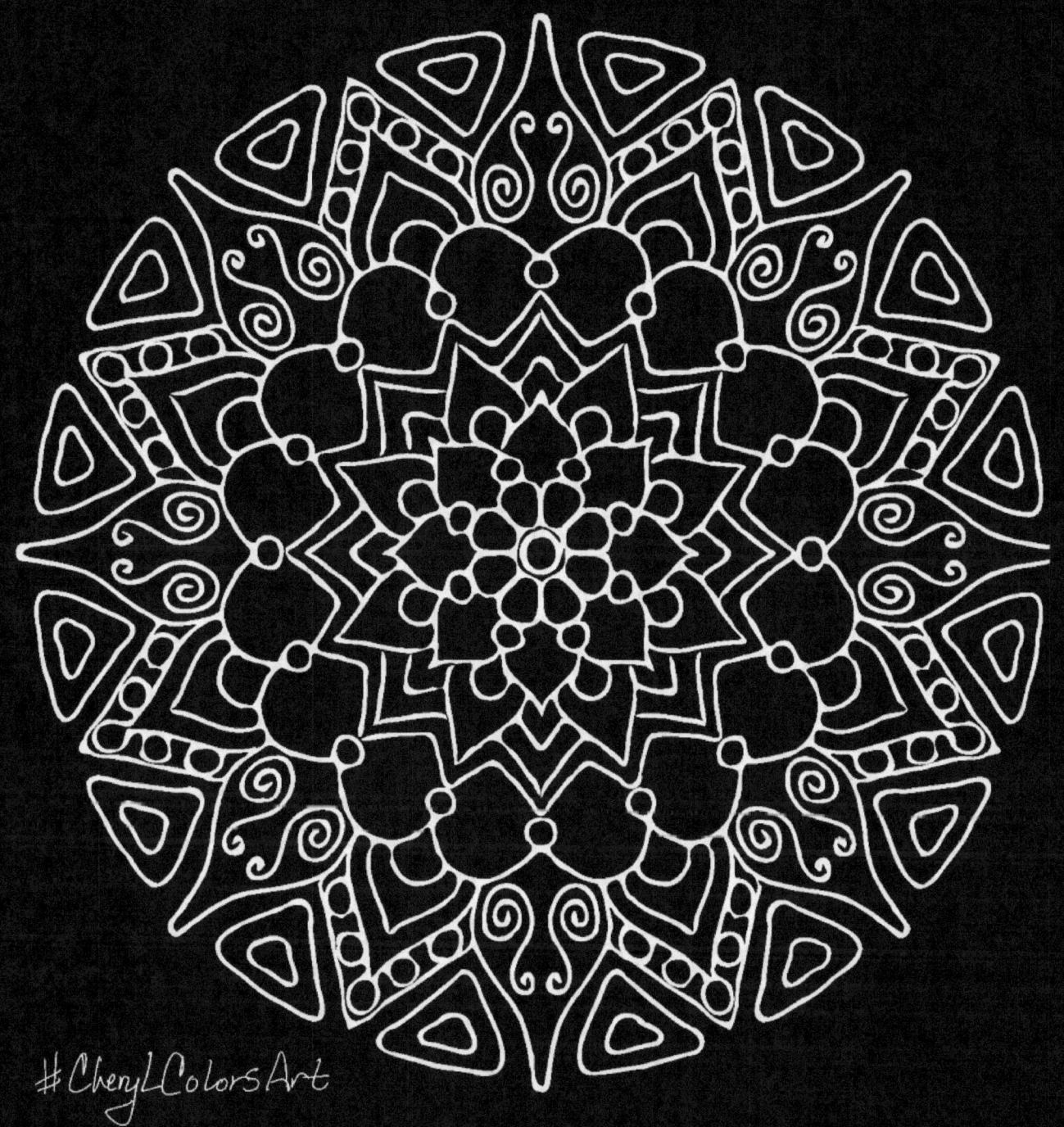

Join and Share your colored pages in the social media groups
Coloring City
&
Coloring with CherylColors

#CherylColorsArt

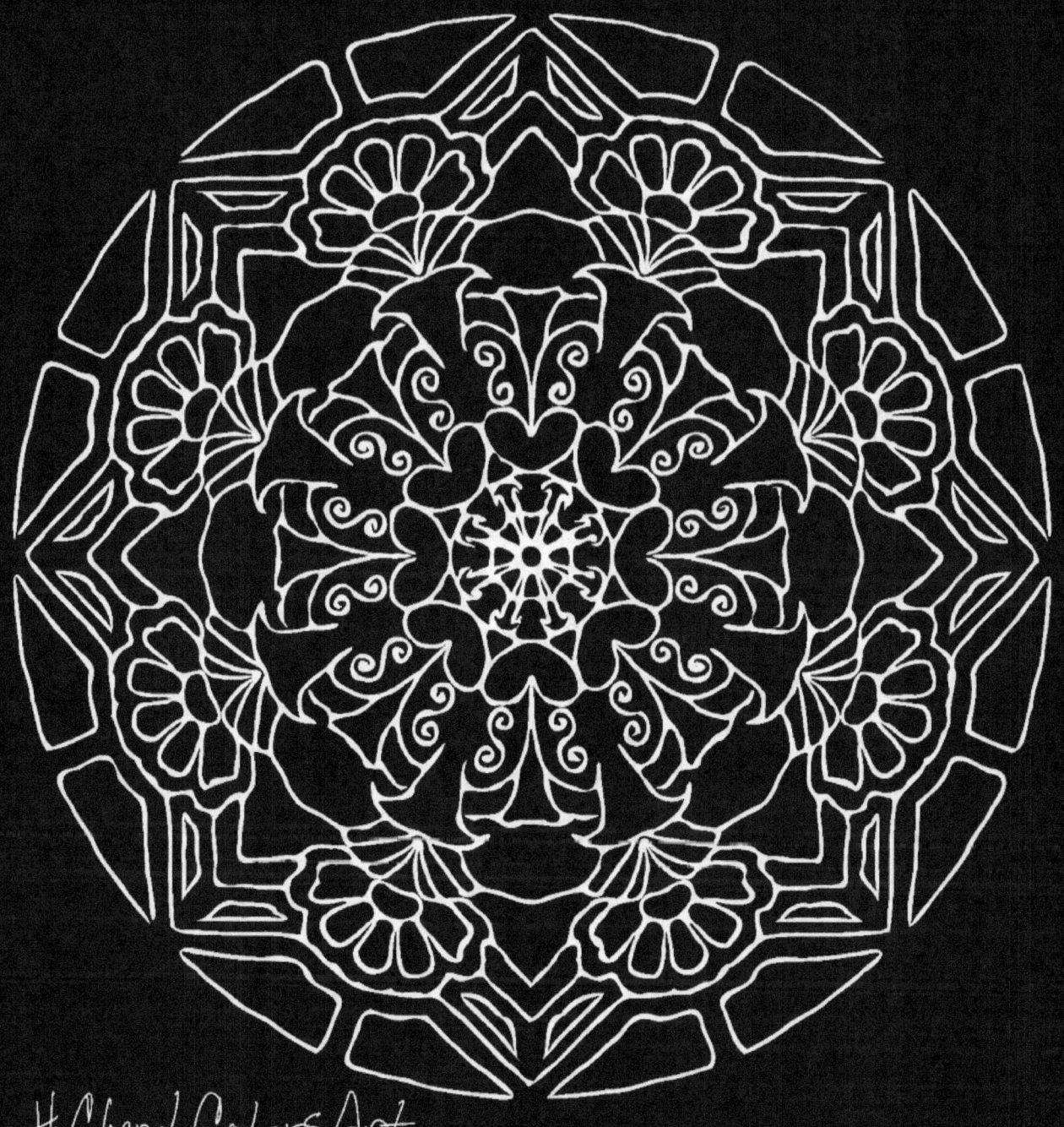

Join and Share your colored pages in the social media groups
Coloring City
&
Coloring with CherylColors

#CherylColorsArt

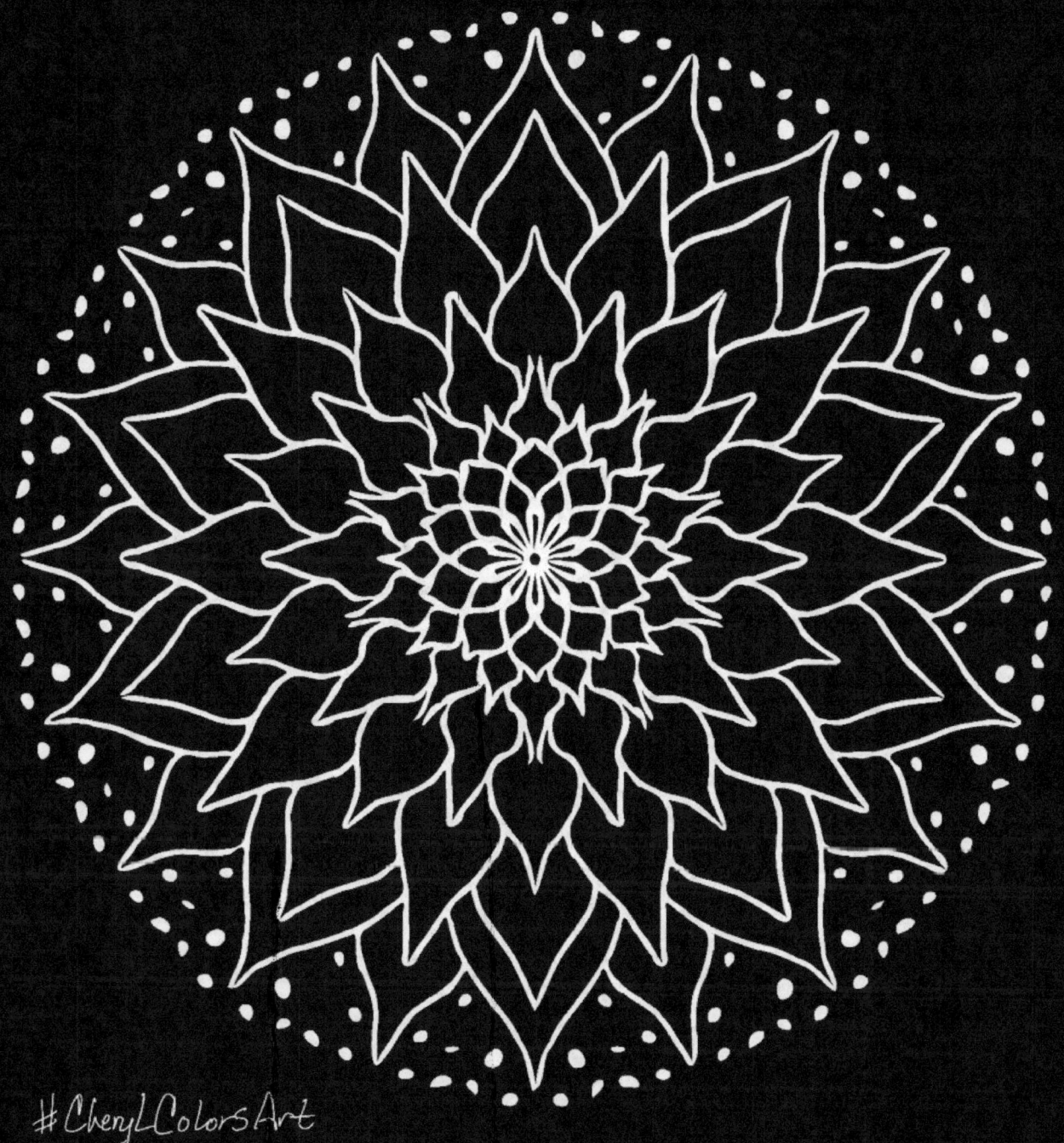

Join and Share your colored pages in the social media groups

Coloring City

&

Coloring with CherylColors

#CherylColorsArt

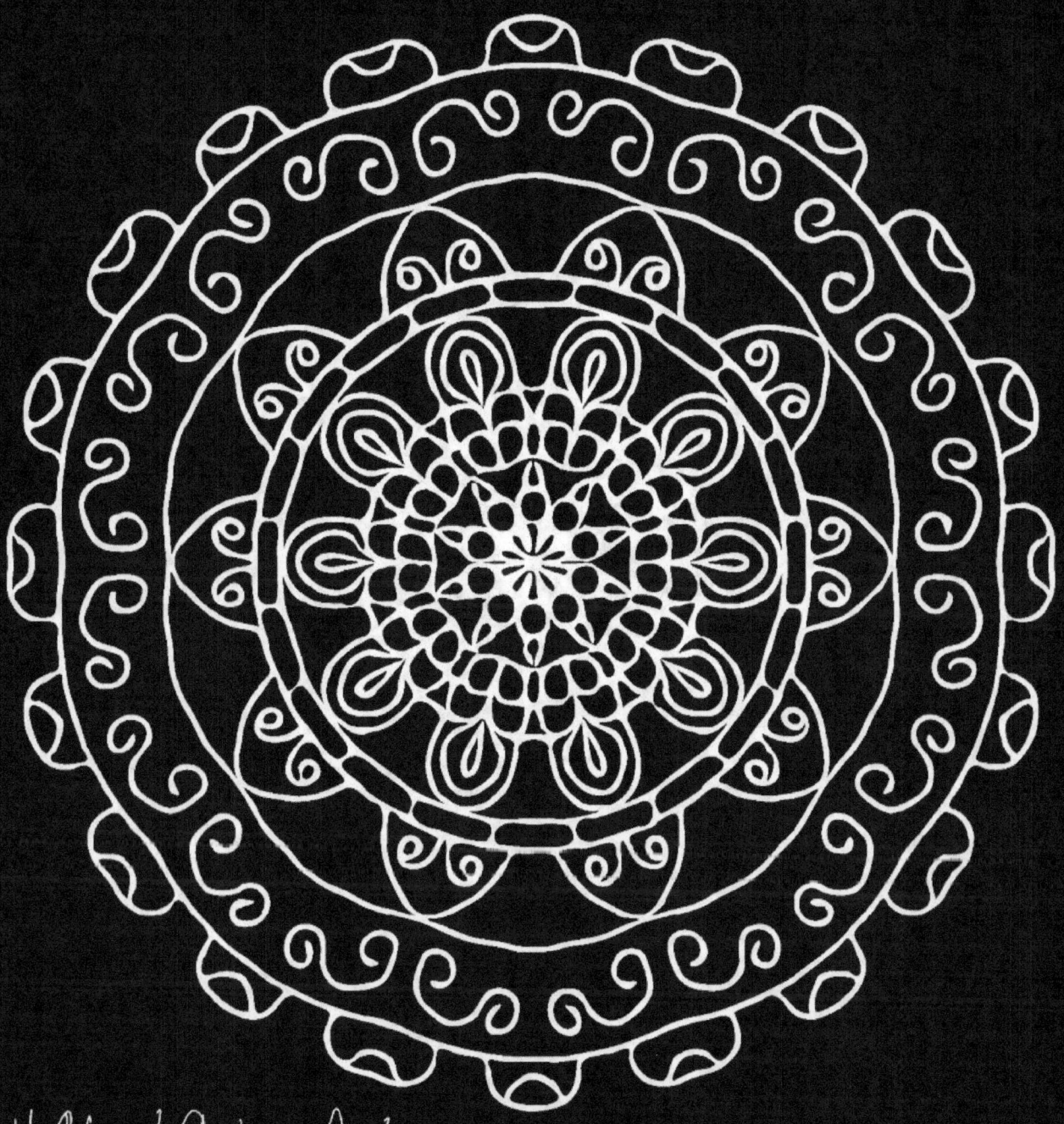

Join and Share your colored pages in the social media groups
Coloring City
&
Coloring with CherylColors

#CherylColorsArt

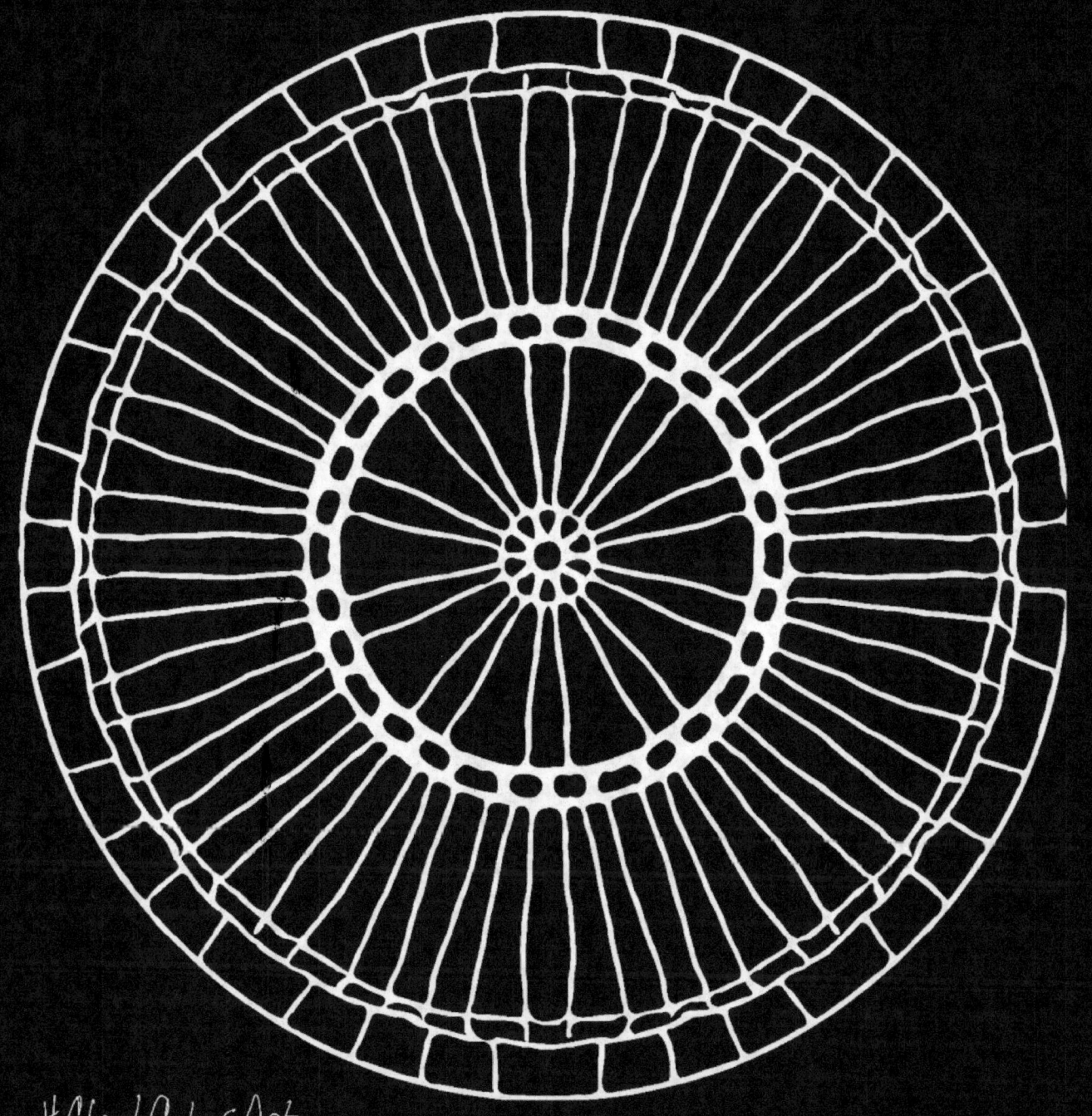

Join and Share your colored pages in the social media groups

Coloring City

&

Coloring with CherylColors

#CherylColorsArt

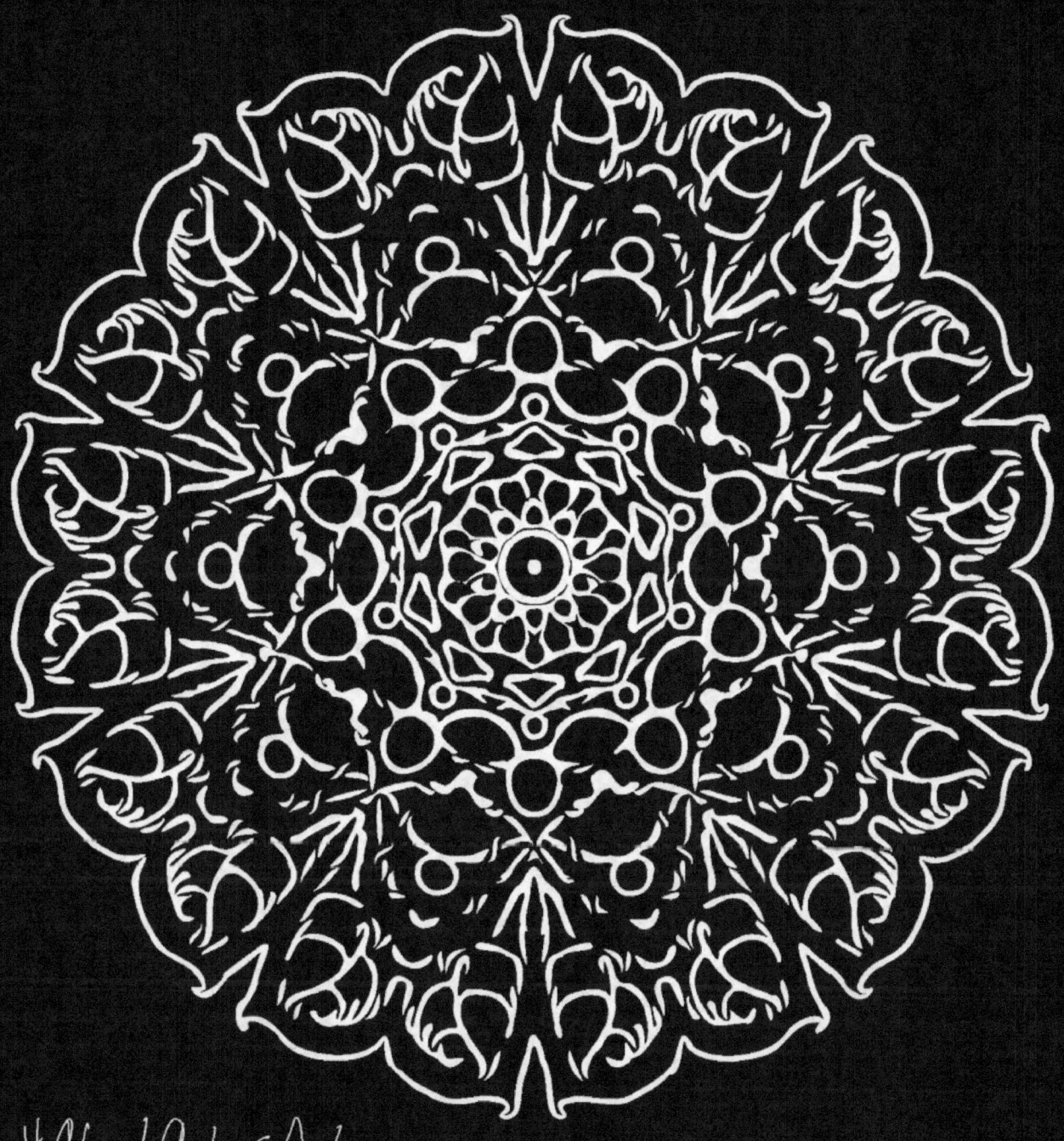

Join and Share your colored pages in the social media groups

Coloring City

&

Coloring with CherylColors

#CherylColorsArt

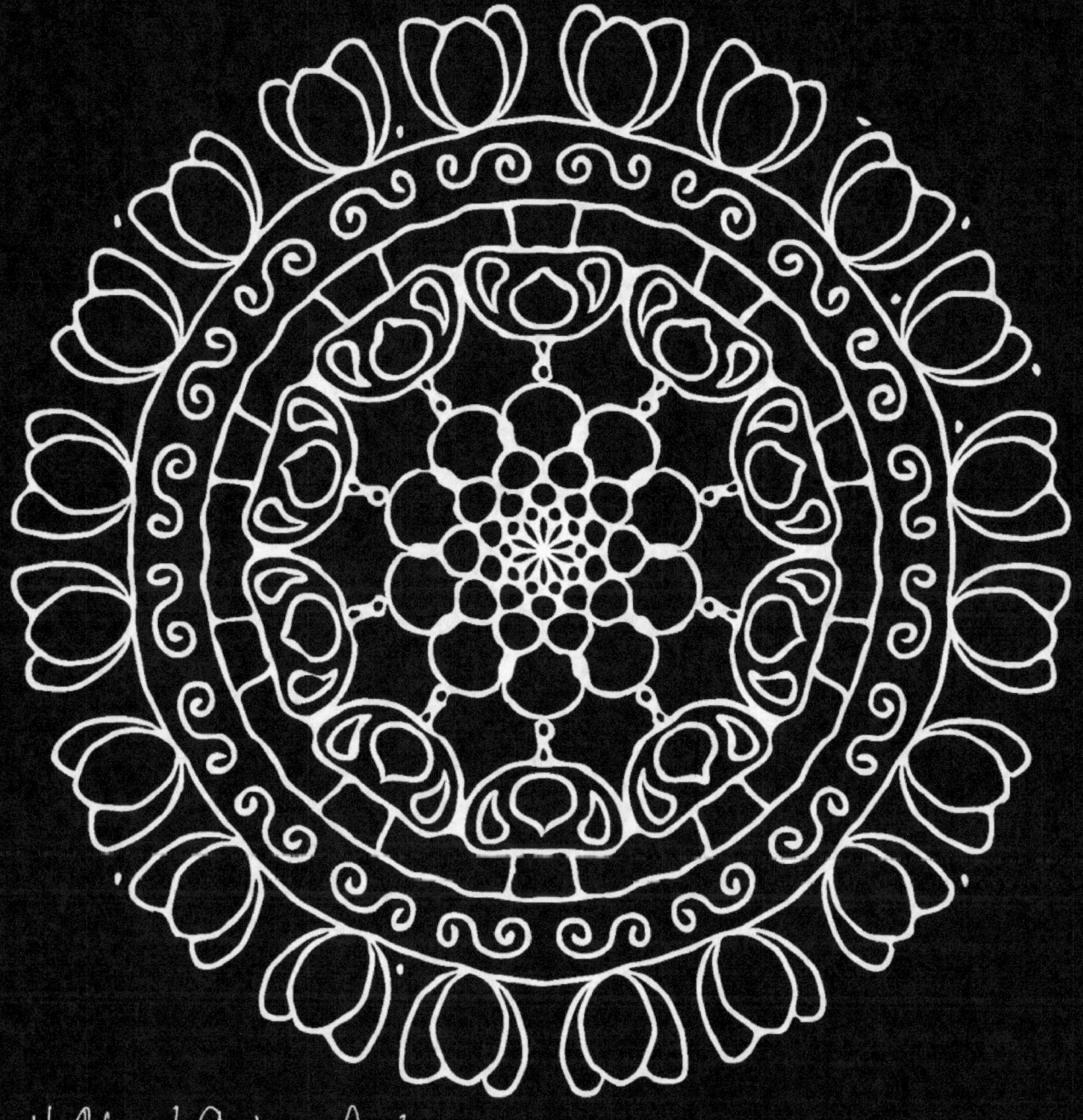

Join and Share your colored pages in the social media groups

Coloring City

&

Coloring with CherylColors

#CherylColorsArt

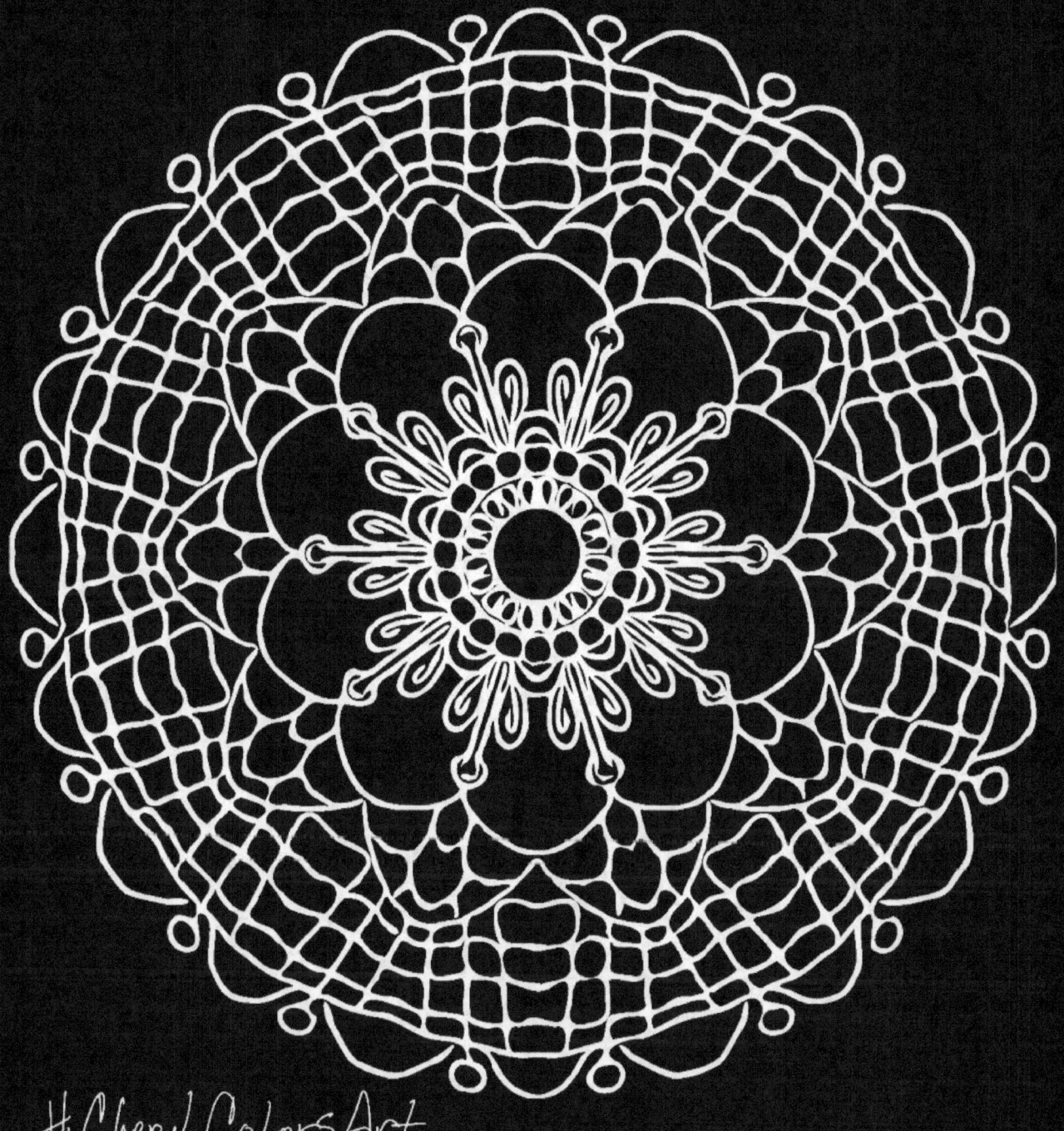

Join and Share your colored pages in the social media groups
Coloring City
&
Coloring with CherylColors

#CherylColorsArt

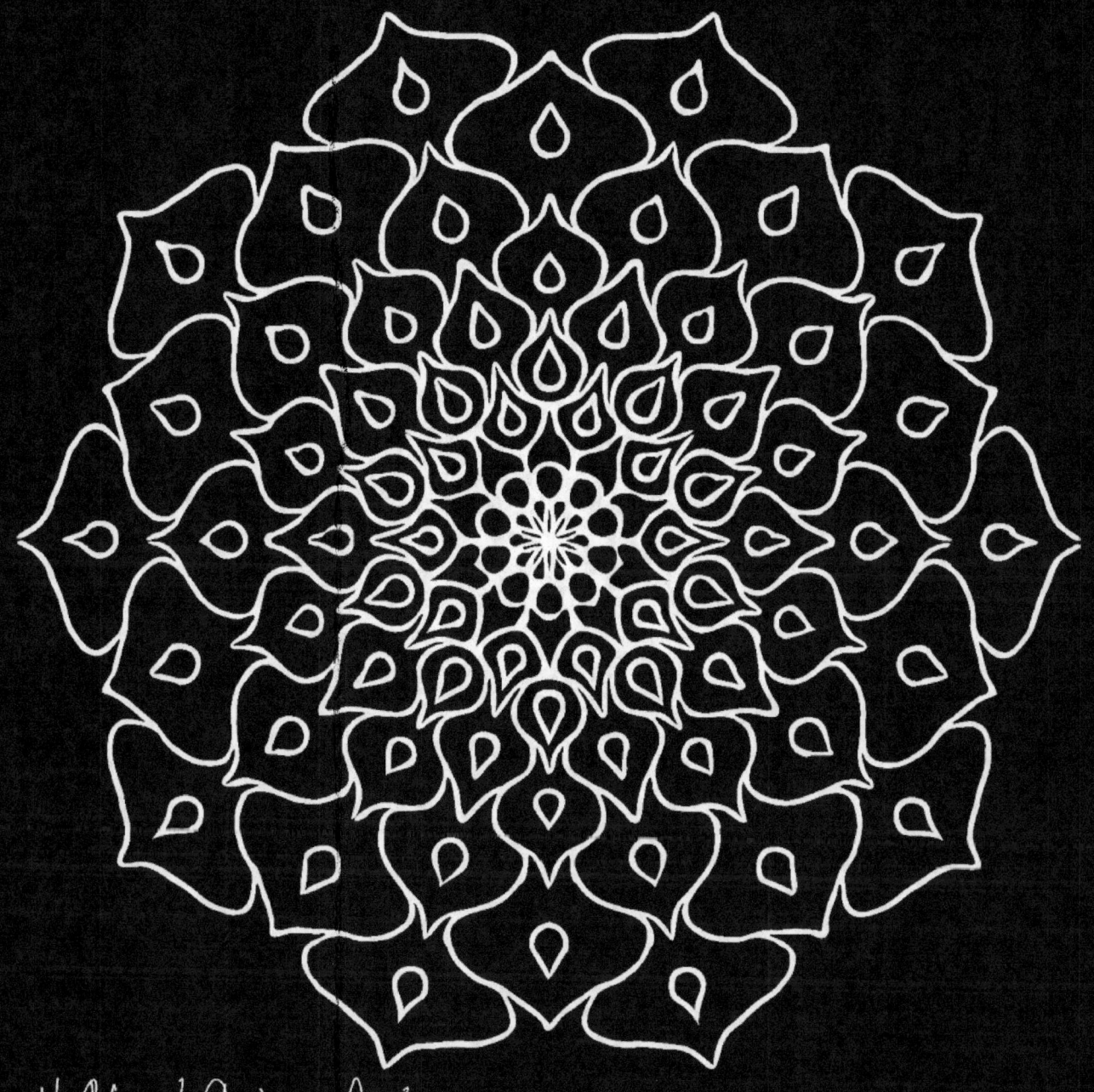

Join and Share your colored pages in the social media groups
Coloring City
&
Coloring with CherylColors

#CherylColorsArt

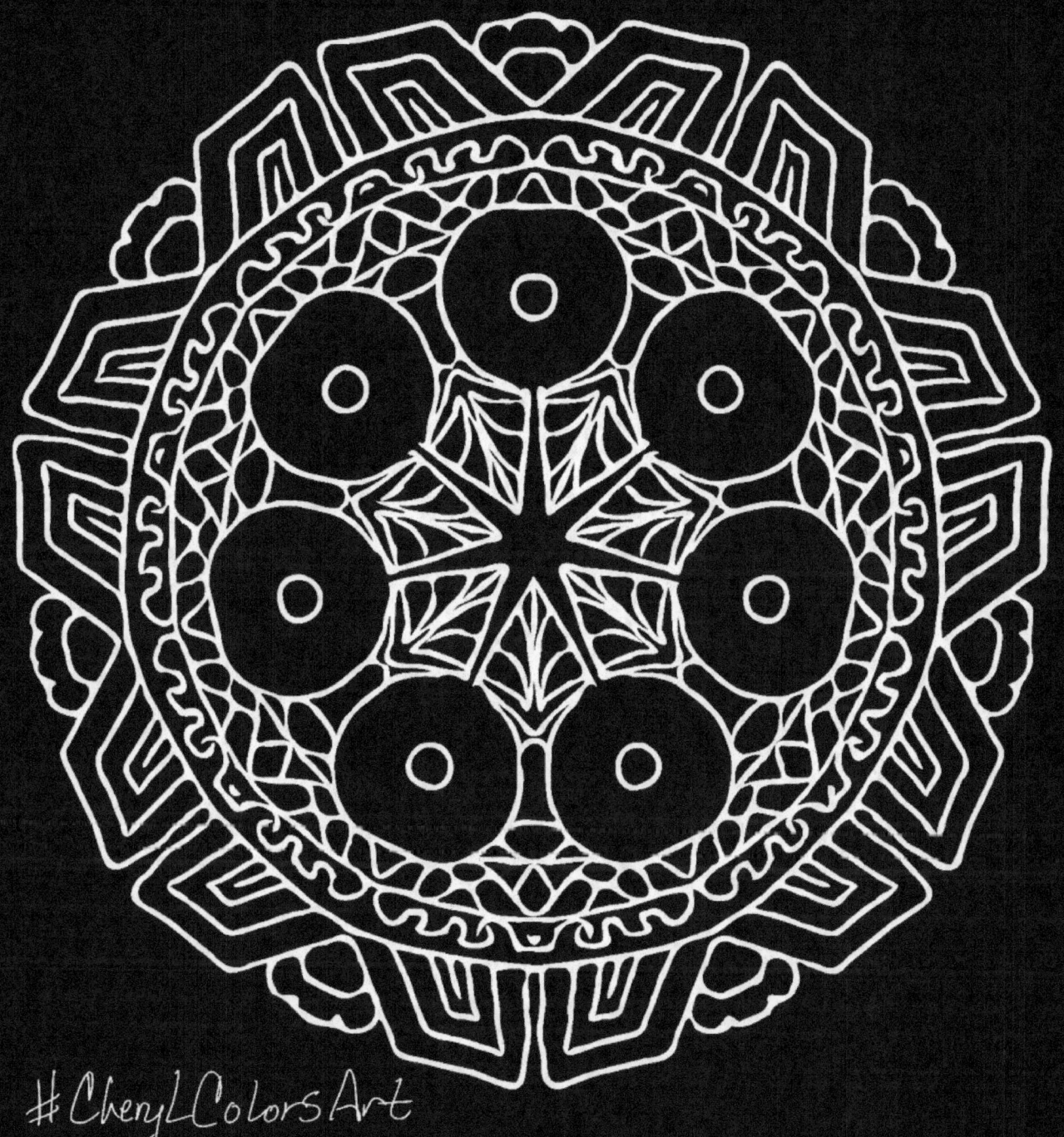

Join and Share your colored pages in the social media groups

Coloring City

&

Coloring with CherylColors

#CherylColorsArt

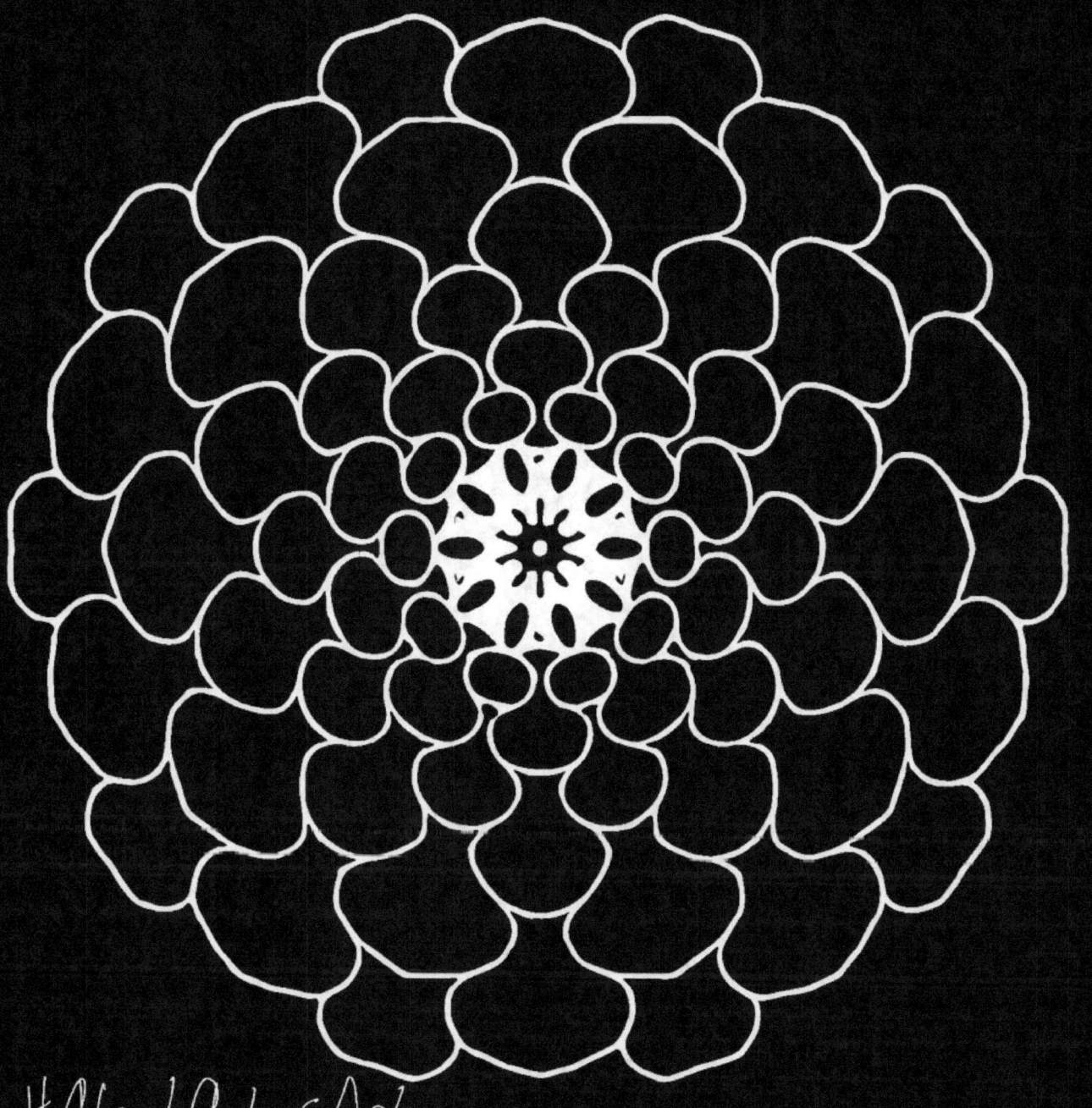

Join and Share your colored pages in the social media groups

Coloring City

&

Coloring with CherylColors

#CherylColorsArt

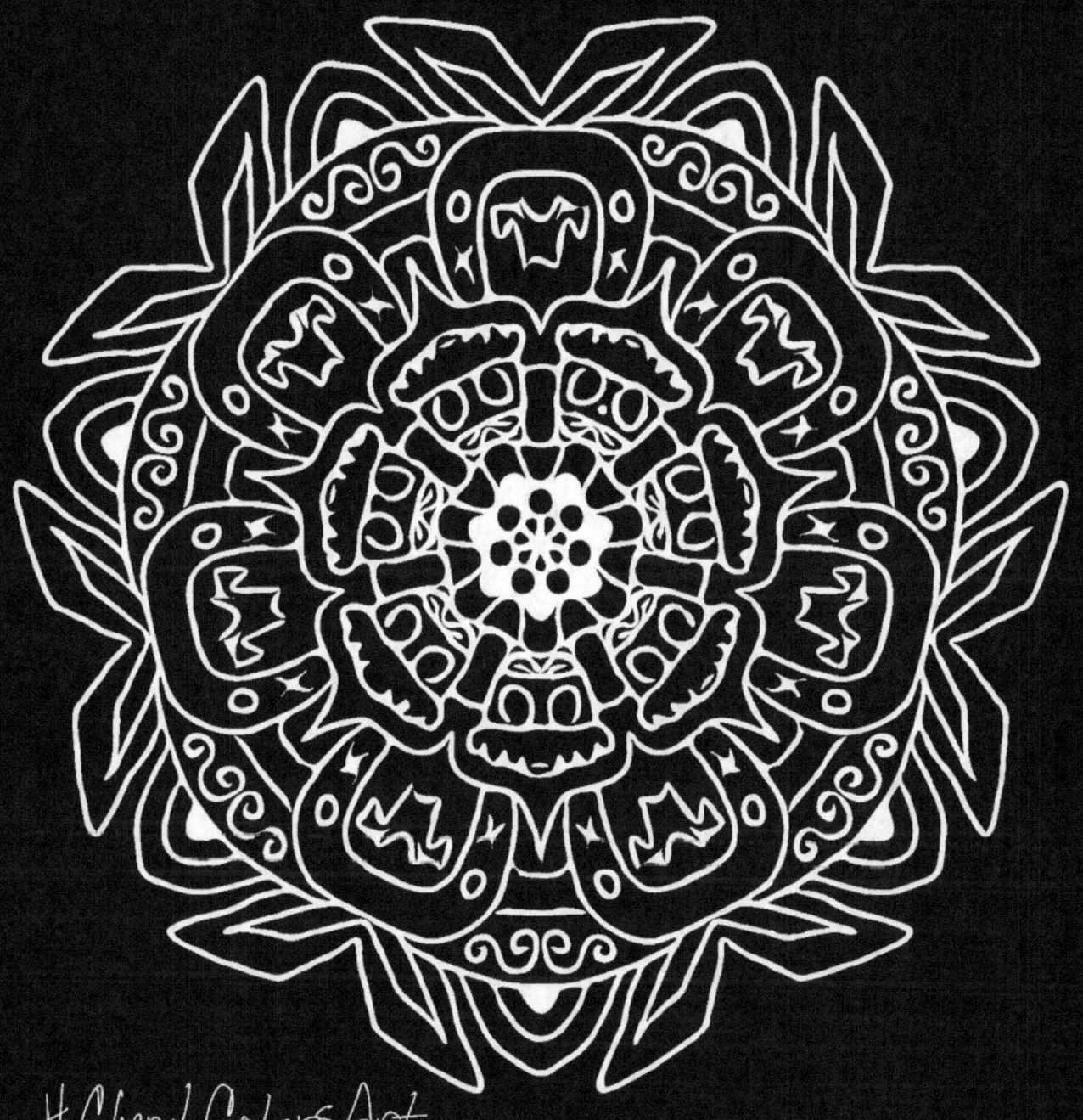

Join and Share your colored pages in the social media groups

Coloring City

&

Coloring with CherylColors

#CherylColorsArt

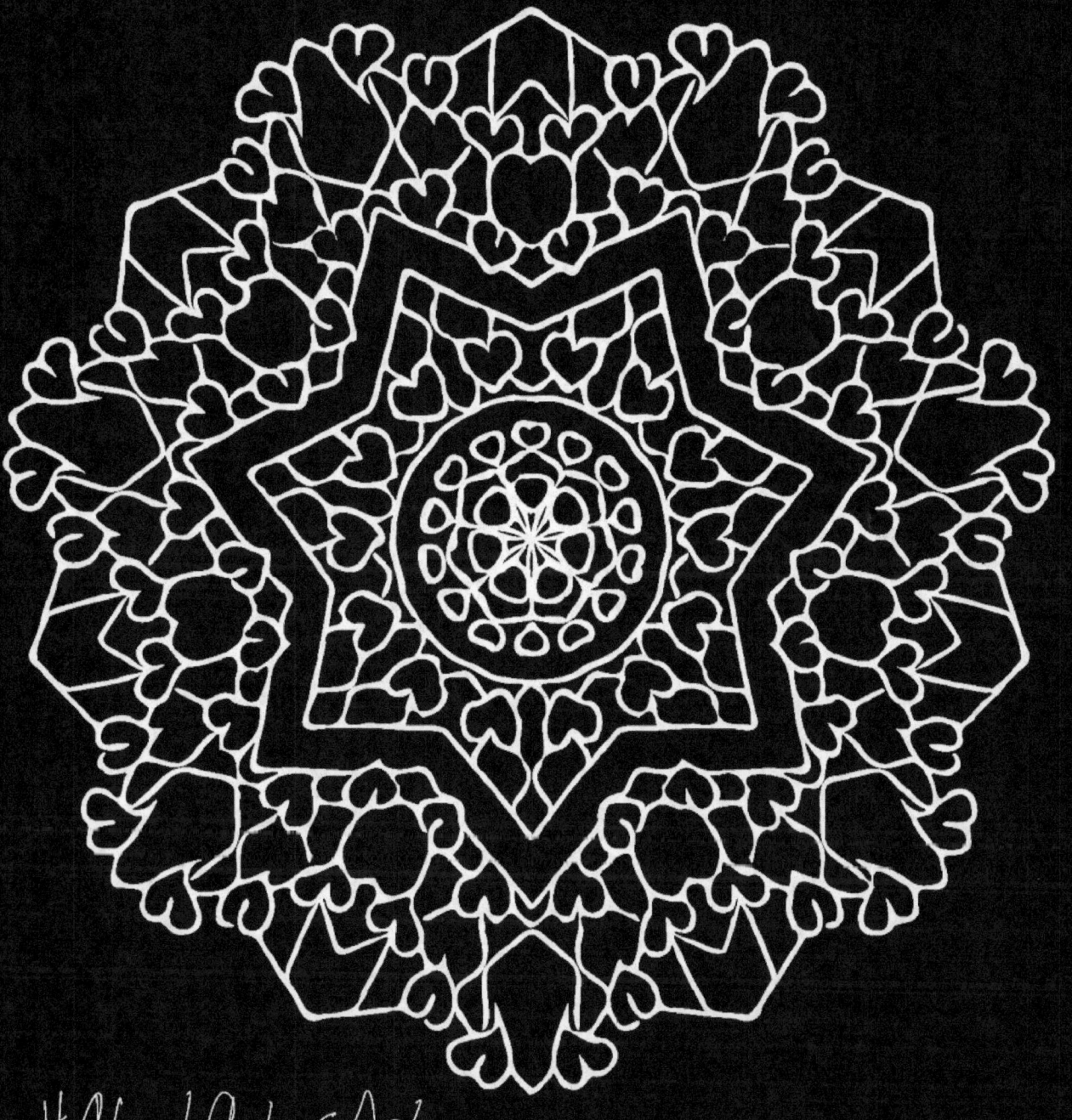

Join and Share your colored pages in the social media groups

Coloring City

&

Coloring with CherylColors

#CherylColorsArt

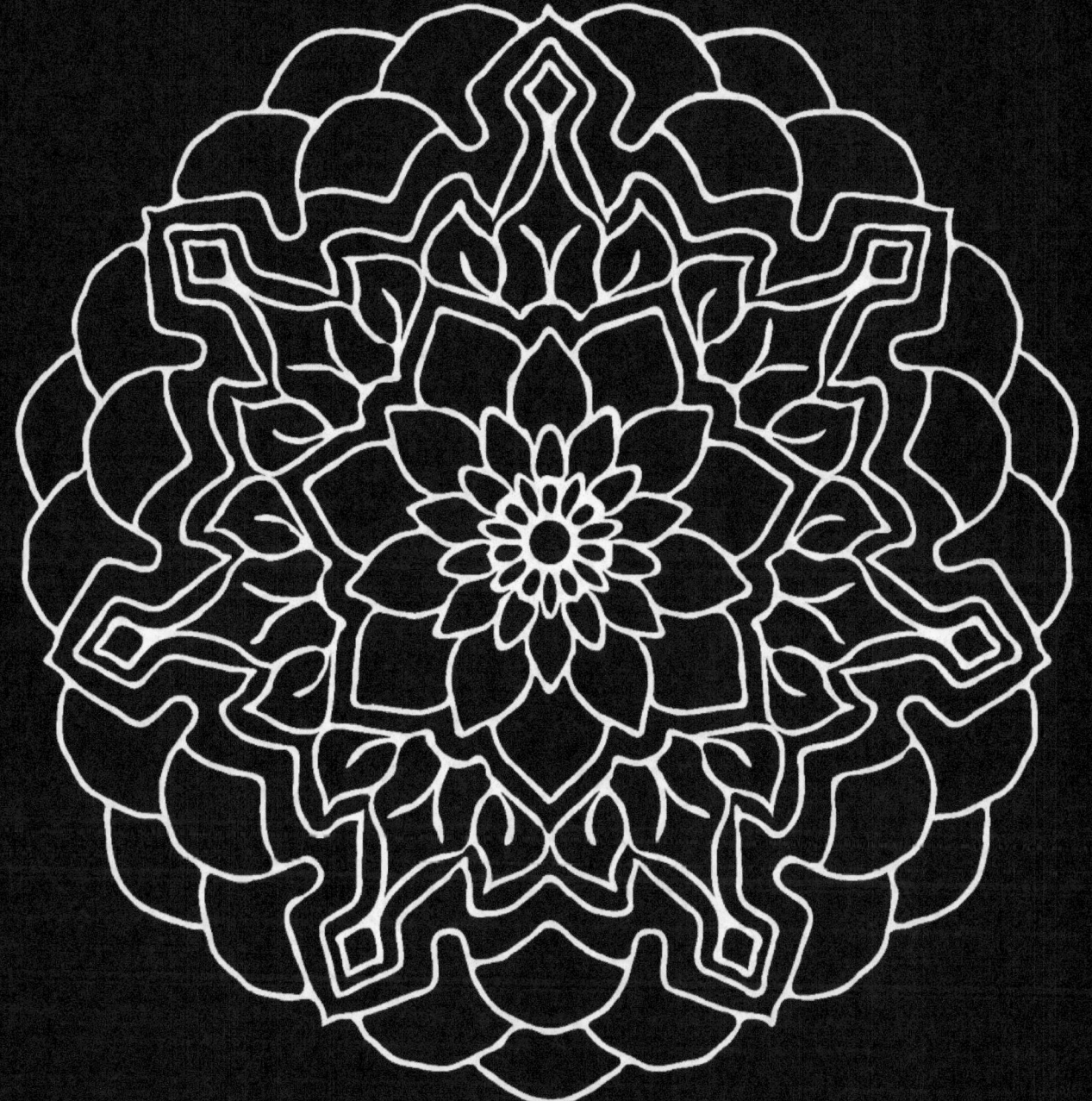

Join and Share your colored pages in the social media groups
Coloring City
&
Coloring with CherylColors

#CherylColorsArt

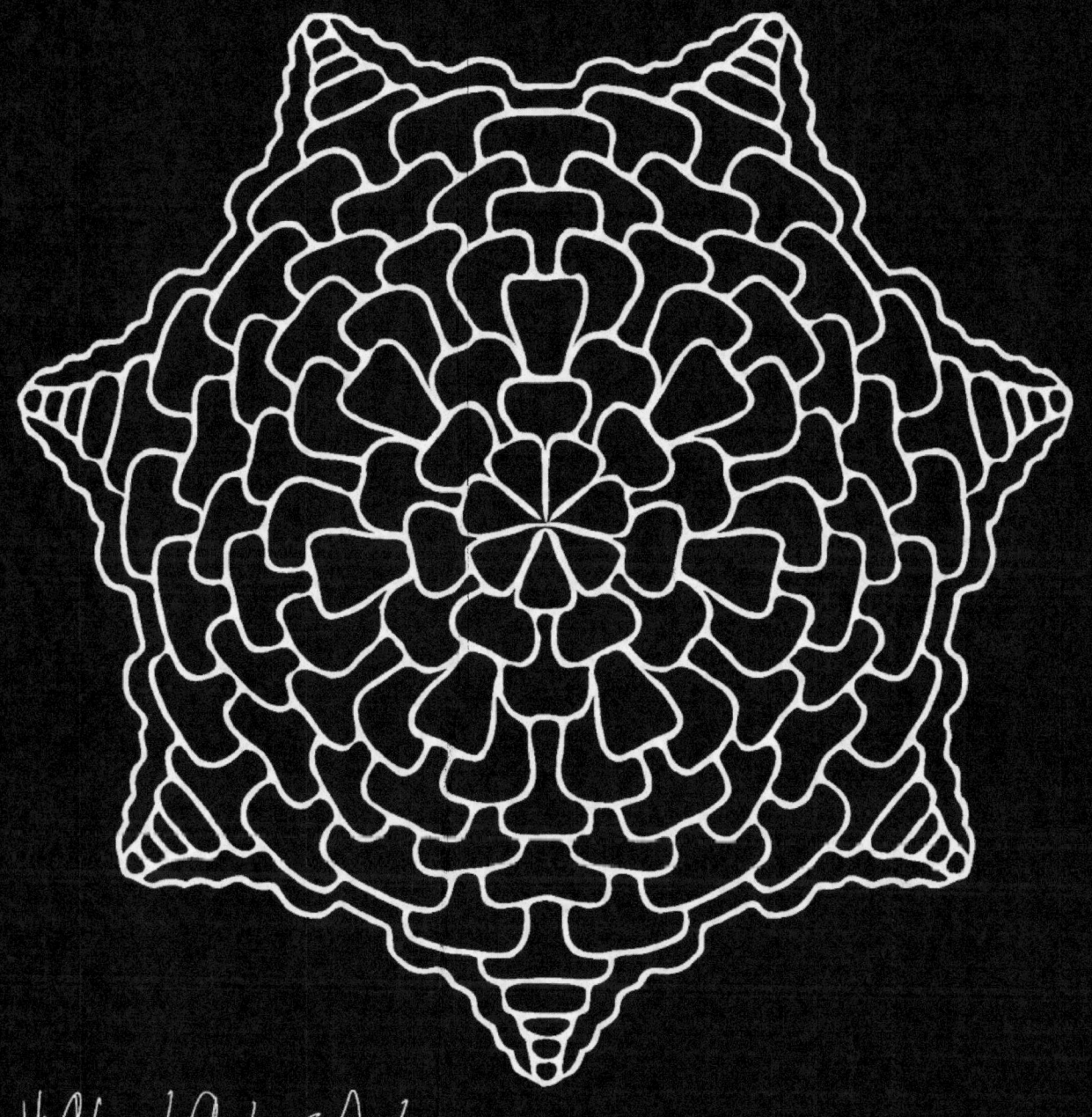
#CherylColorsArt

Join and Share your colored pages in the social media groups
Coloring City
&
Coloring with CherylColors

#CherylColorsArt

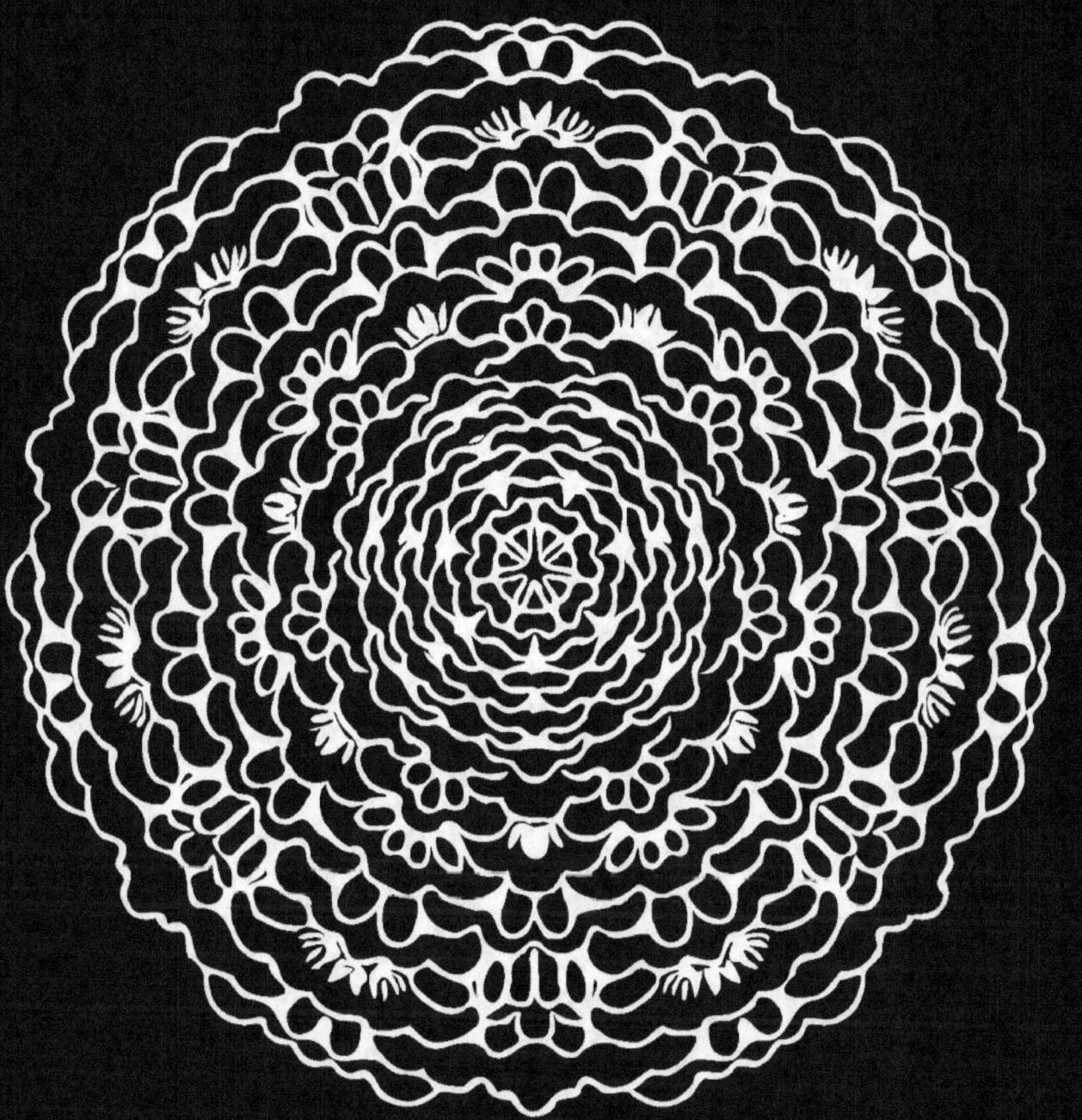

Join and Share your colored pages in the social media groups
Coloring City
&
Coloring with CherylColors

#CherylColorsArt

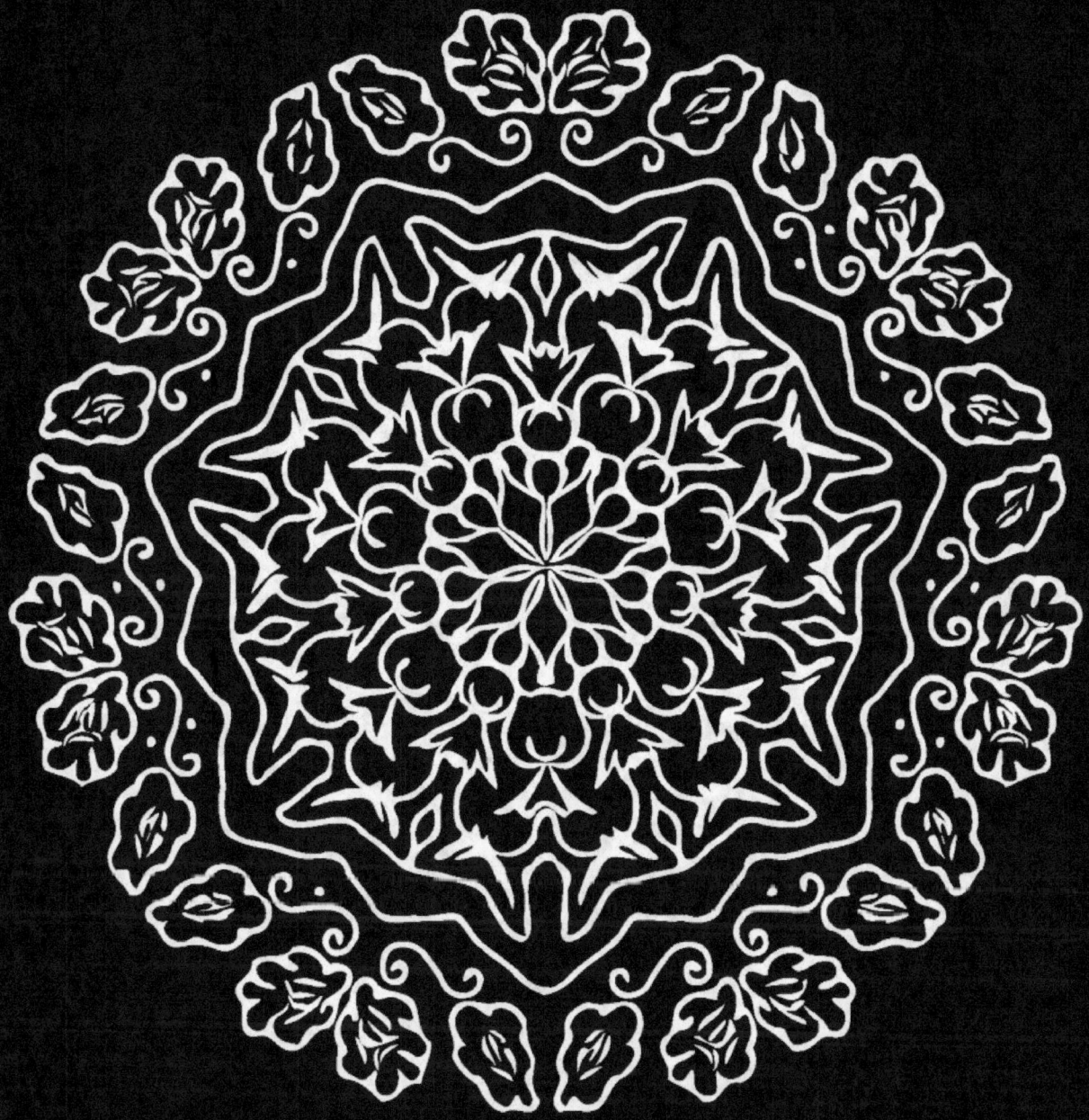

Join and Share your colored pages in the social media groups
Coloring City
&
Coloring with CherylColors

#CherylColorsArt

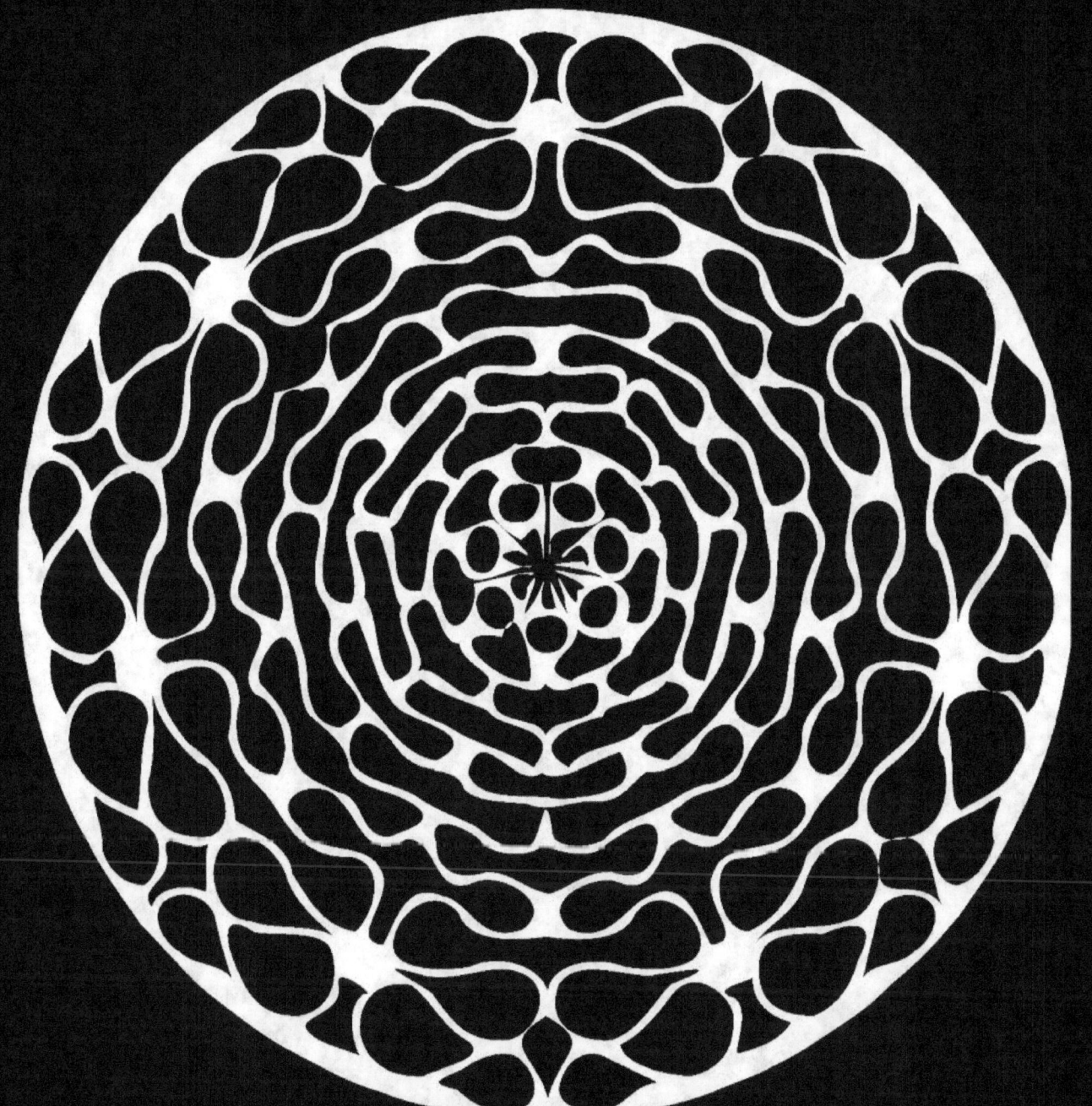

Join and Share your colored pages in the social media groups

Coloring City

&

Coloring with CherylColors

#CherylColorsArt

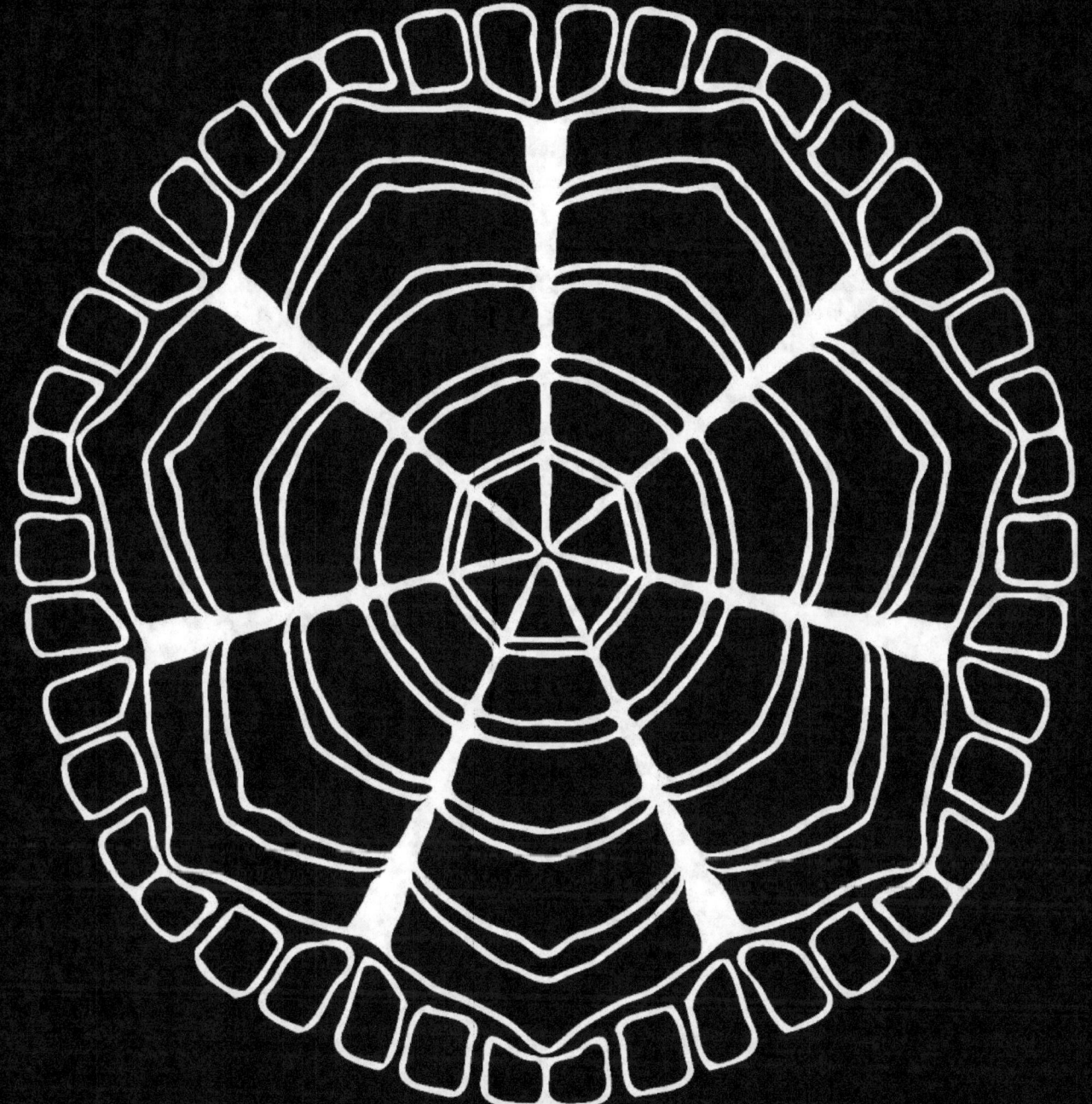

Join and Share your colored pages in the social media groups
Coloring City
&
Coloring with CherylColors

#CherylColorsArt

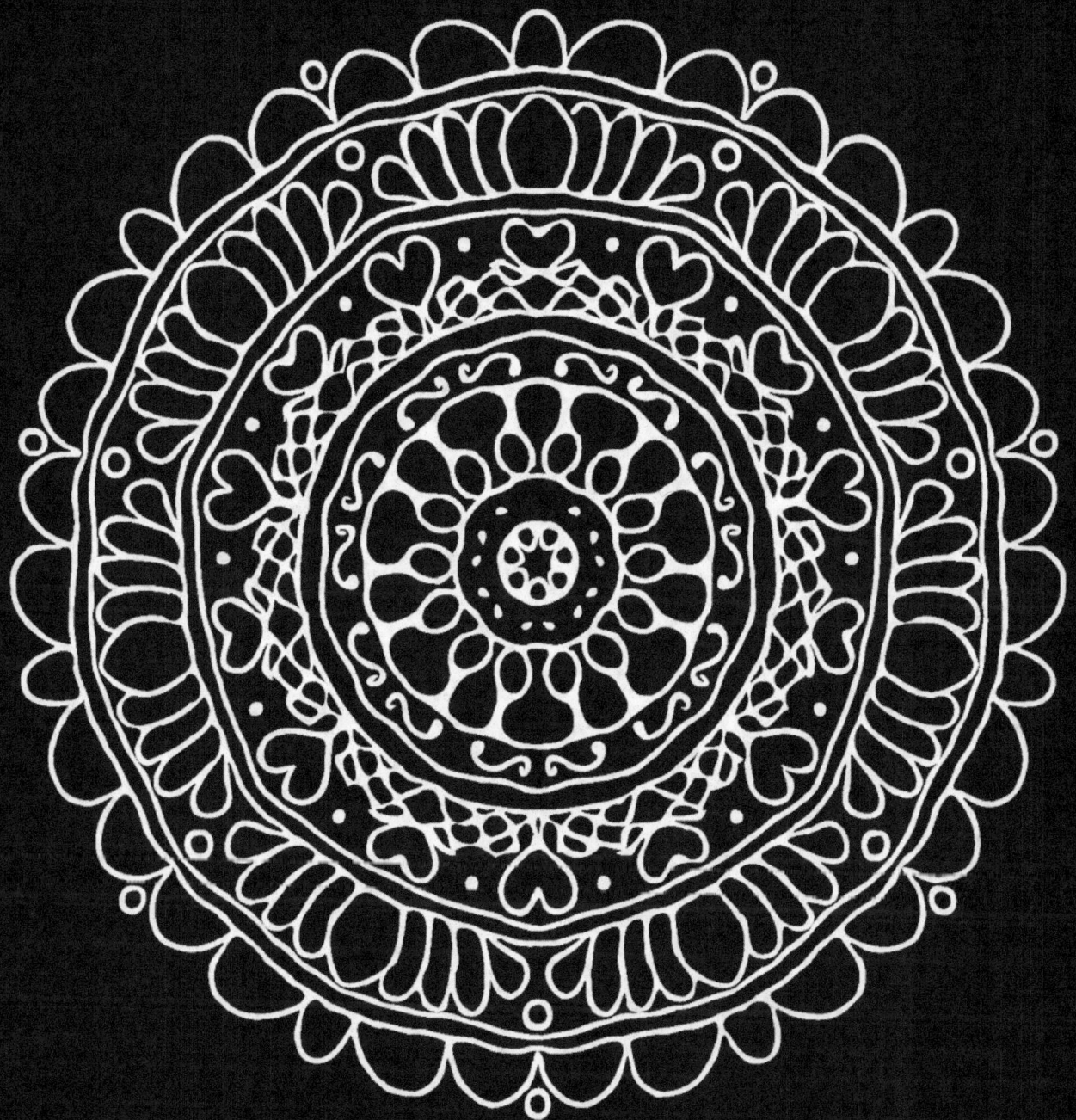

Join and Share your colored pages in the social media groups
Coloring City
&
Coloring with CherylColors

#CherylColorsArt

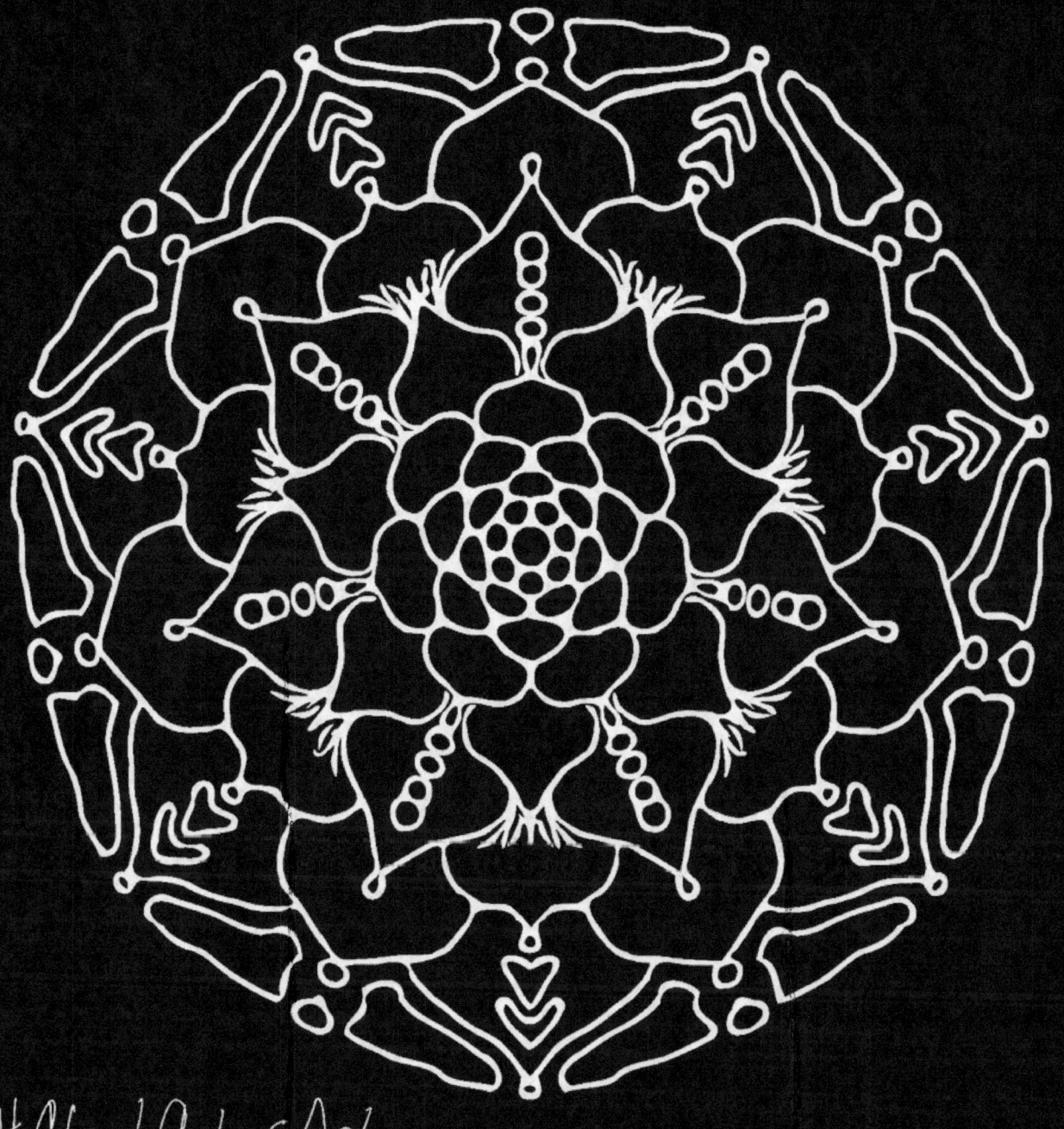
#CherylColorsArt

Join and Share your colored pages in the social media groups
Coloring City
&
Coloring with CherylColors

#CherylColorsArt

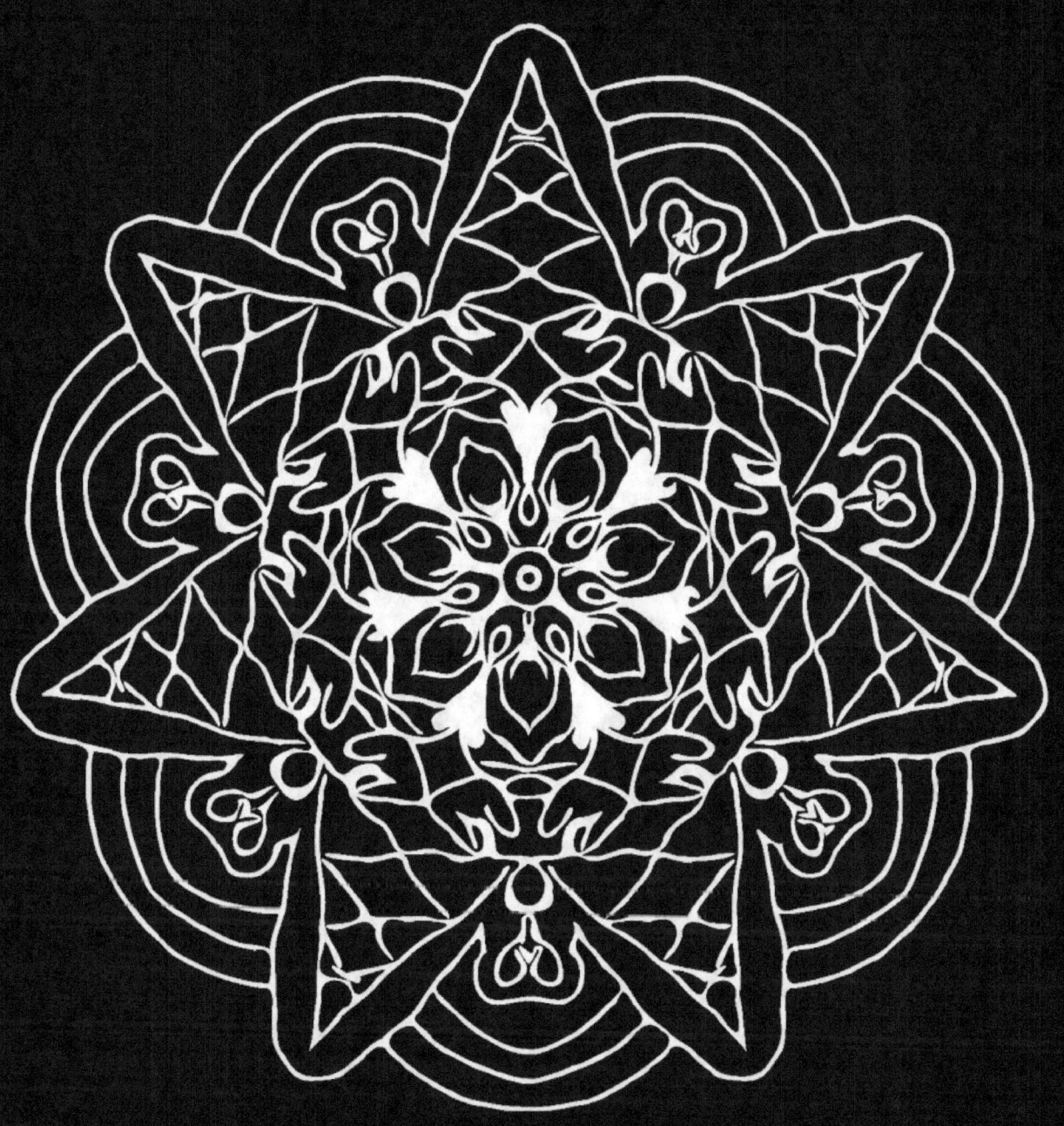

Join and Share your colored pages in the social media groups
Coloring City
&
Coloring with CherylColors

#CherylColorsArt

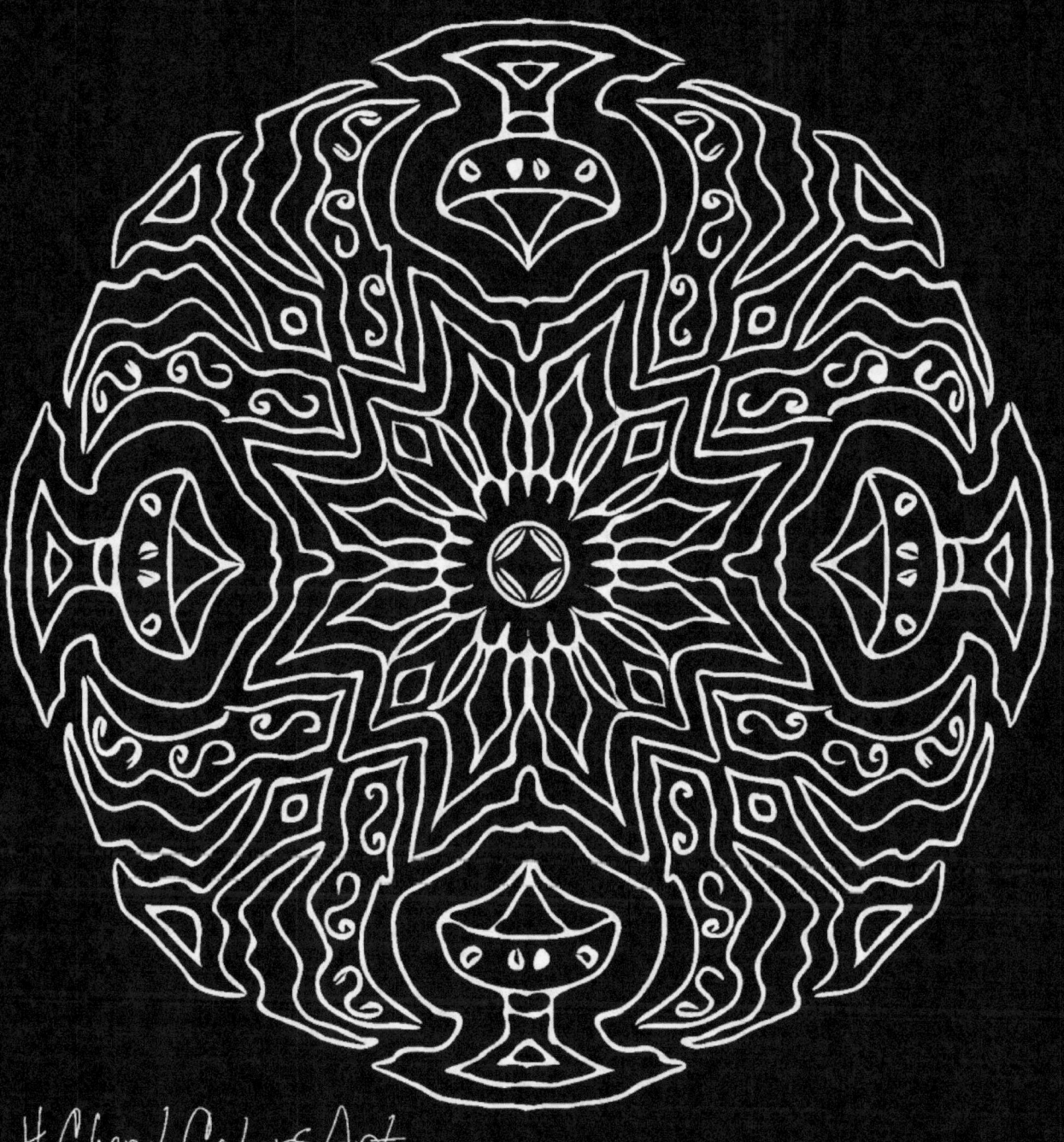

Join and Share your colored pages in the social media groups
Coloring City
&
Coloring with CherylColors

#CherylColorsArt

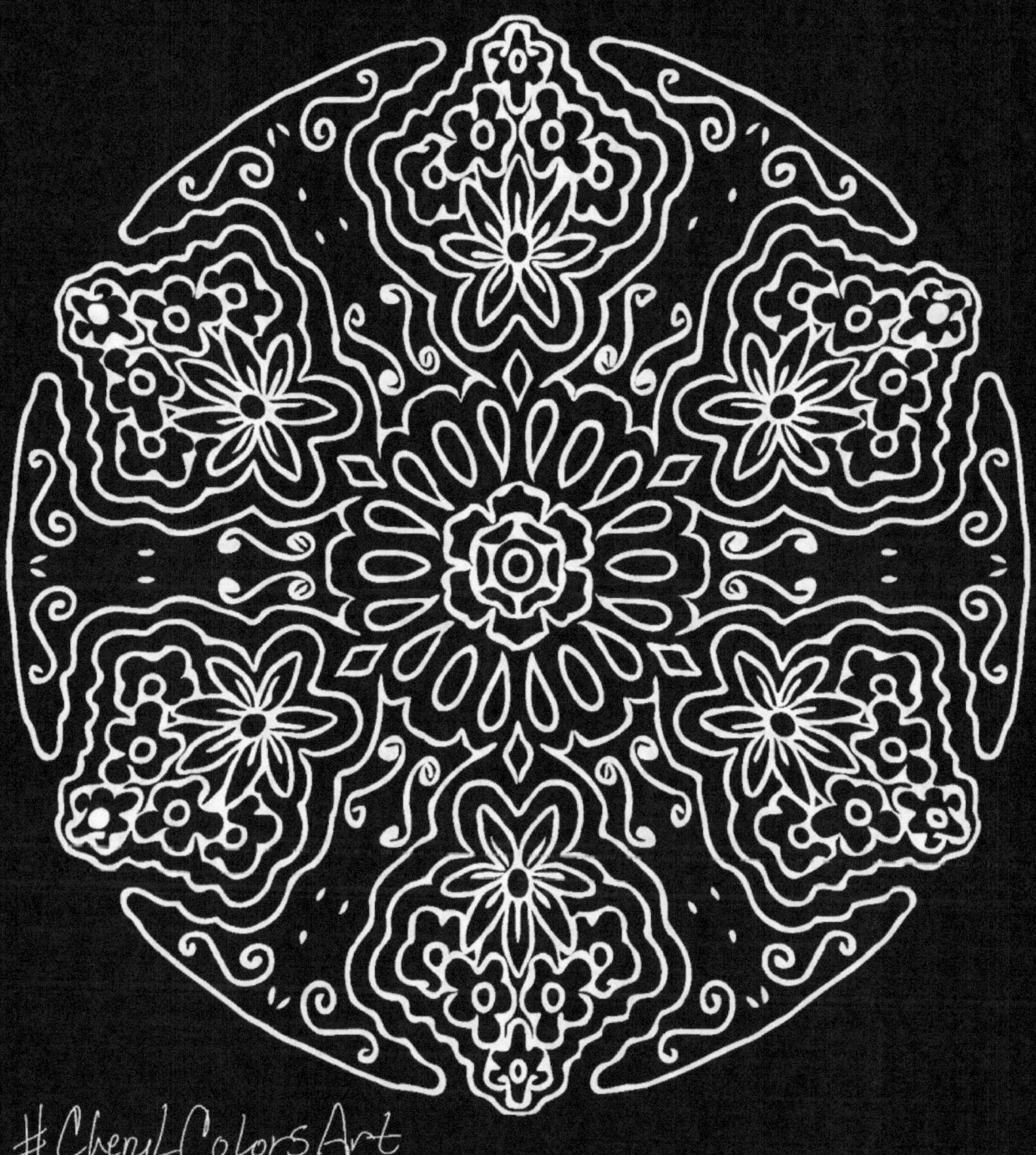

Join and Share your colored pages in the social media groups

Coloring City

&

Coloring with CherylColors

#CherylColorsArt

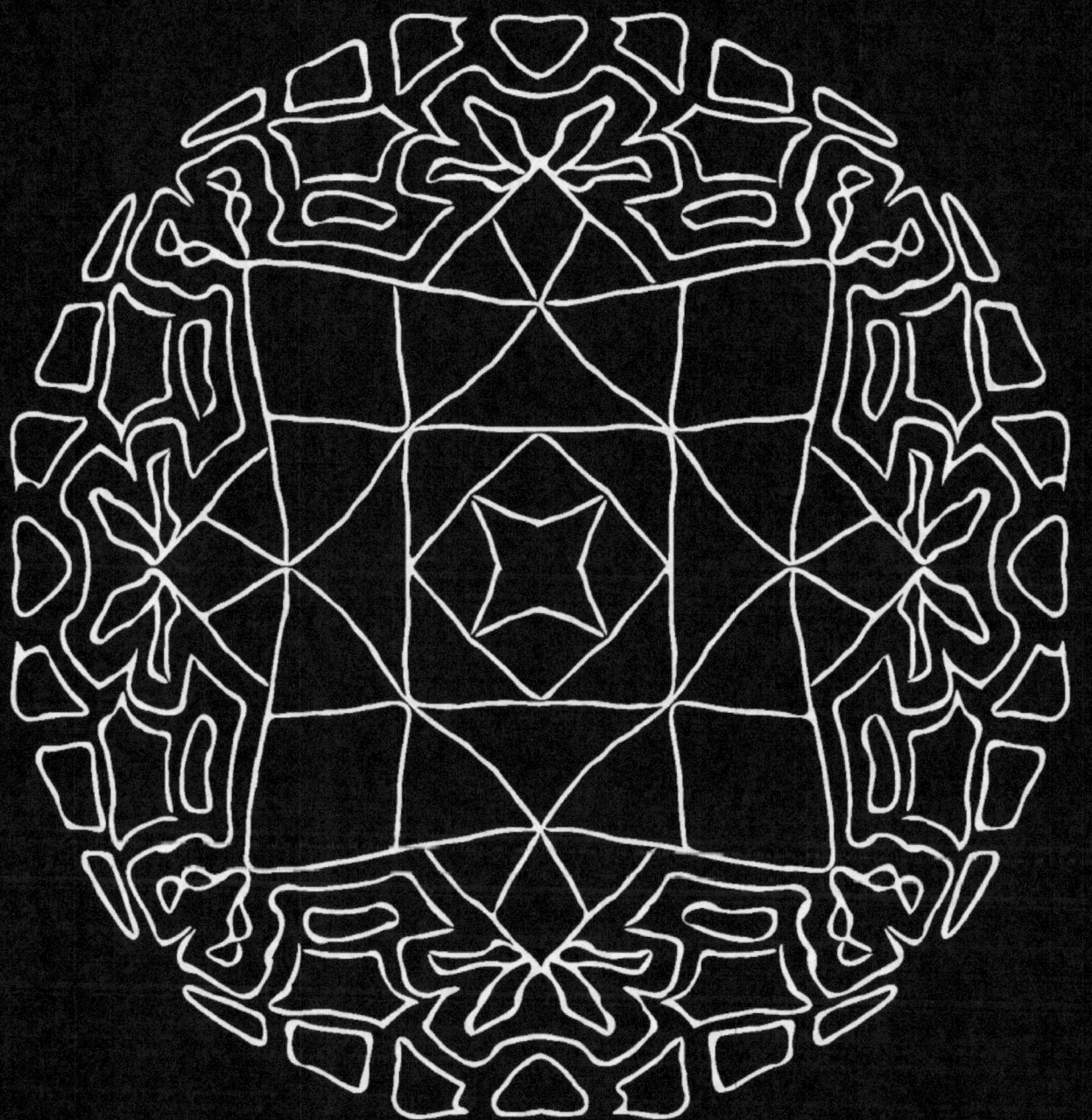

Join and Share your colored pages in the social media groups

Coloring City

&

Coloring with CherylColors

#CherylColorsArt

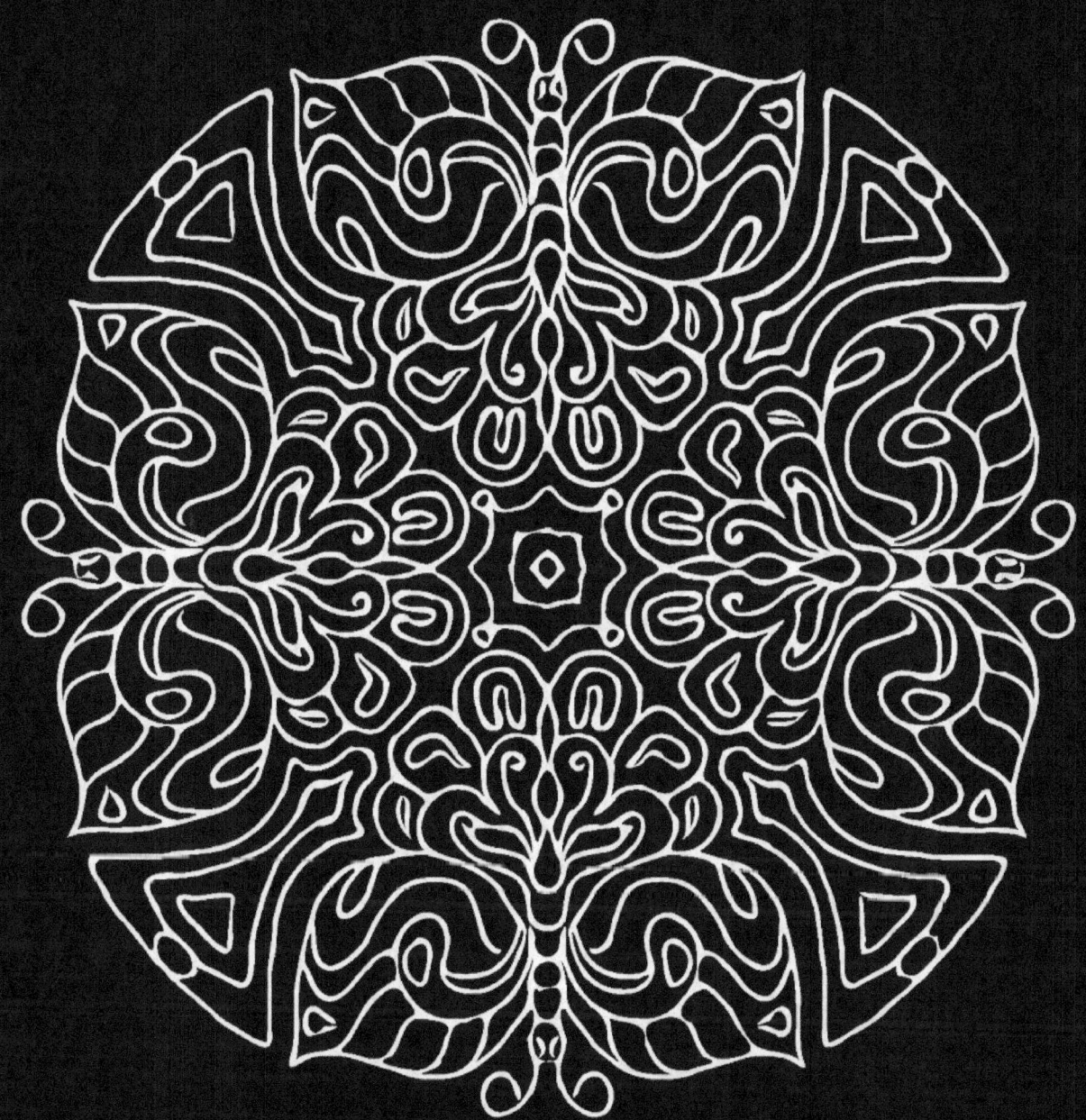

Join and Share your colored pages in the social media groups
Coloring City
&
Coloring with CherylColors

#CherylColorsArt

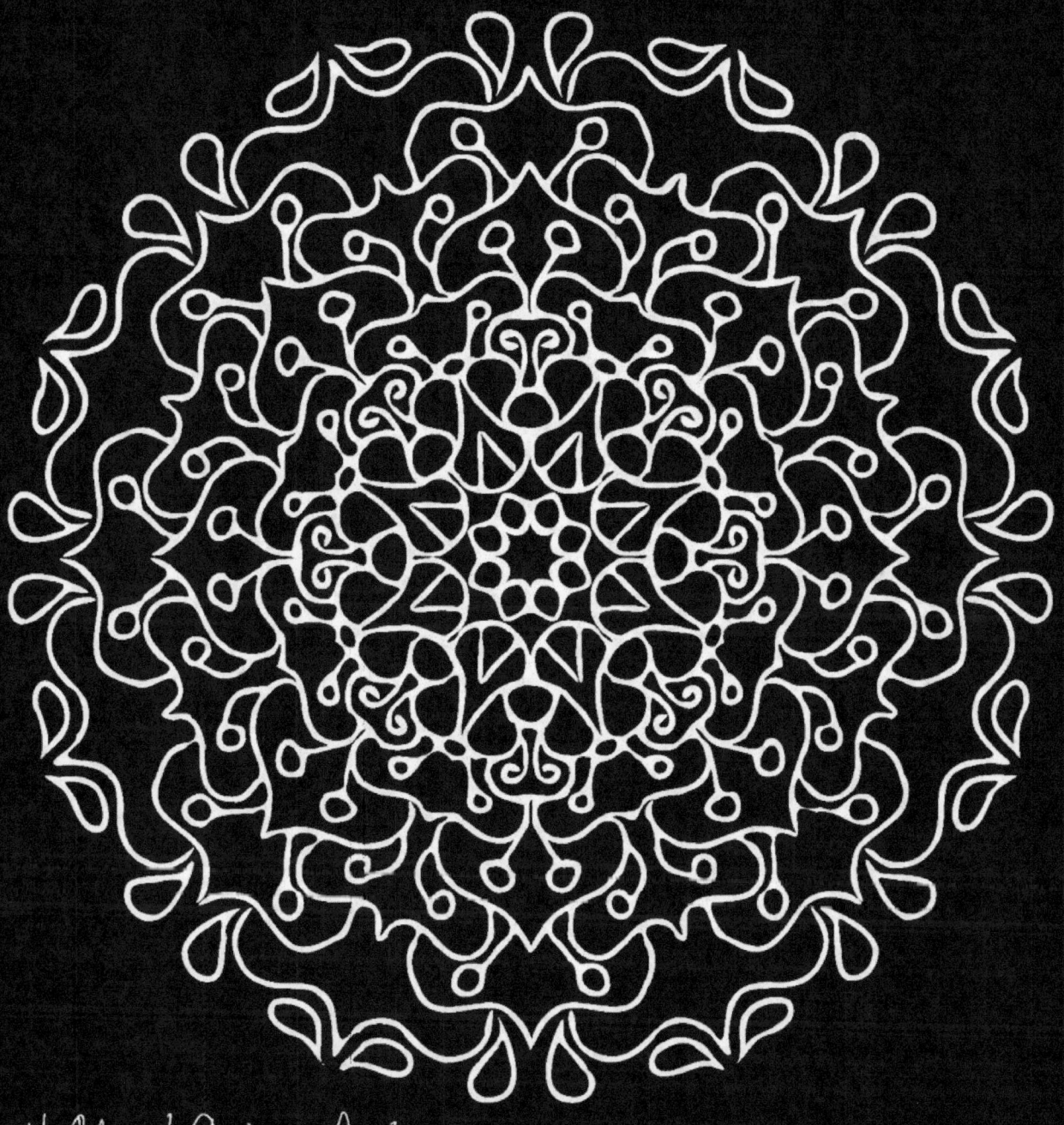

Join and Share your colored pages in the social media groups
Coloring City
&
Coloring with CherylColors

#CherylColorsArt

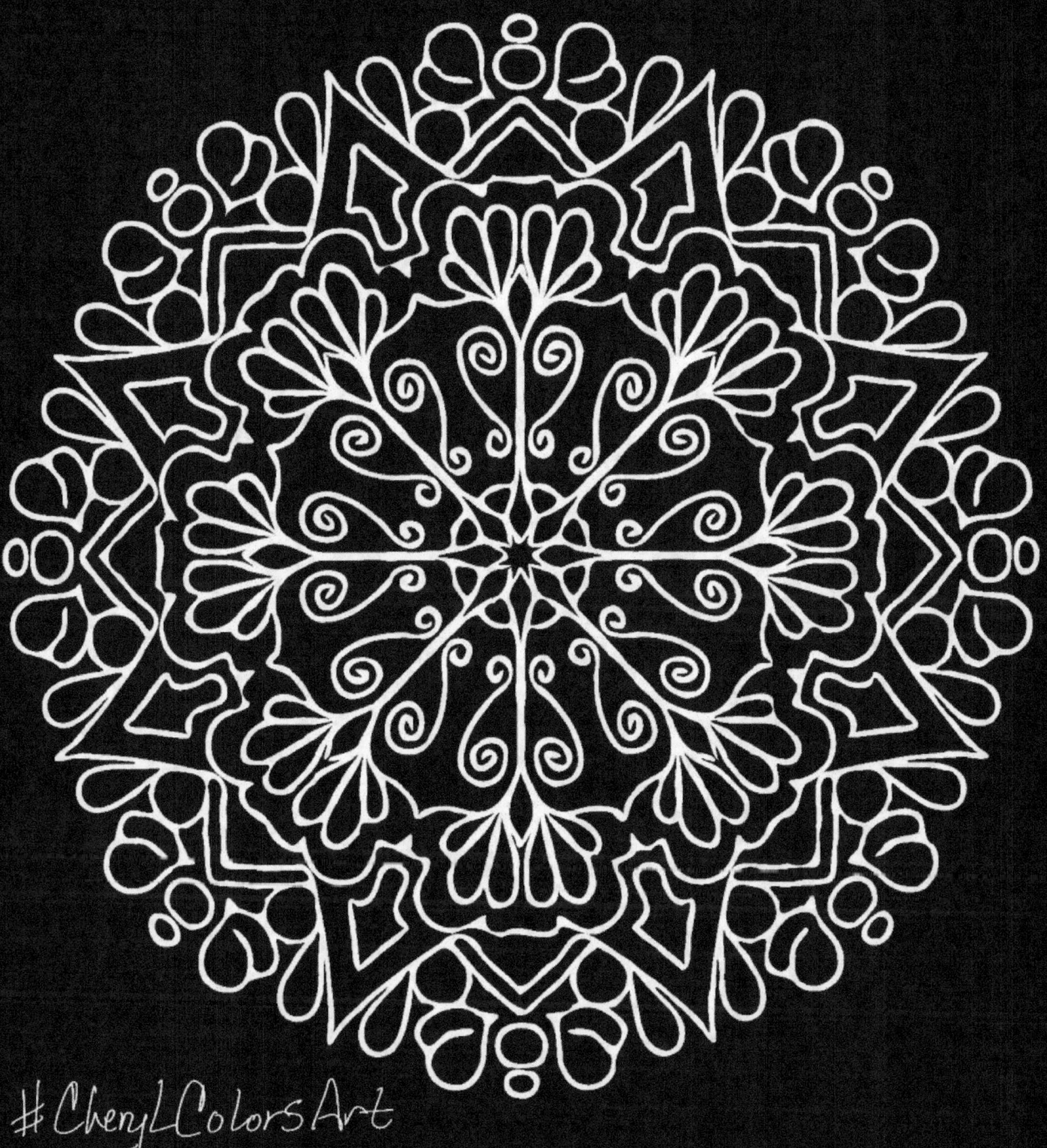

Join and Share your colored pages in the social media groups

Coloring City

&

Coloring with CherylColors

#CherylColorsArt

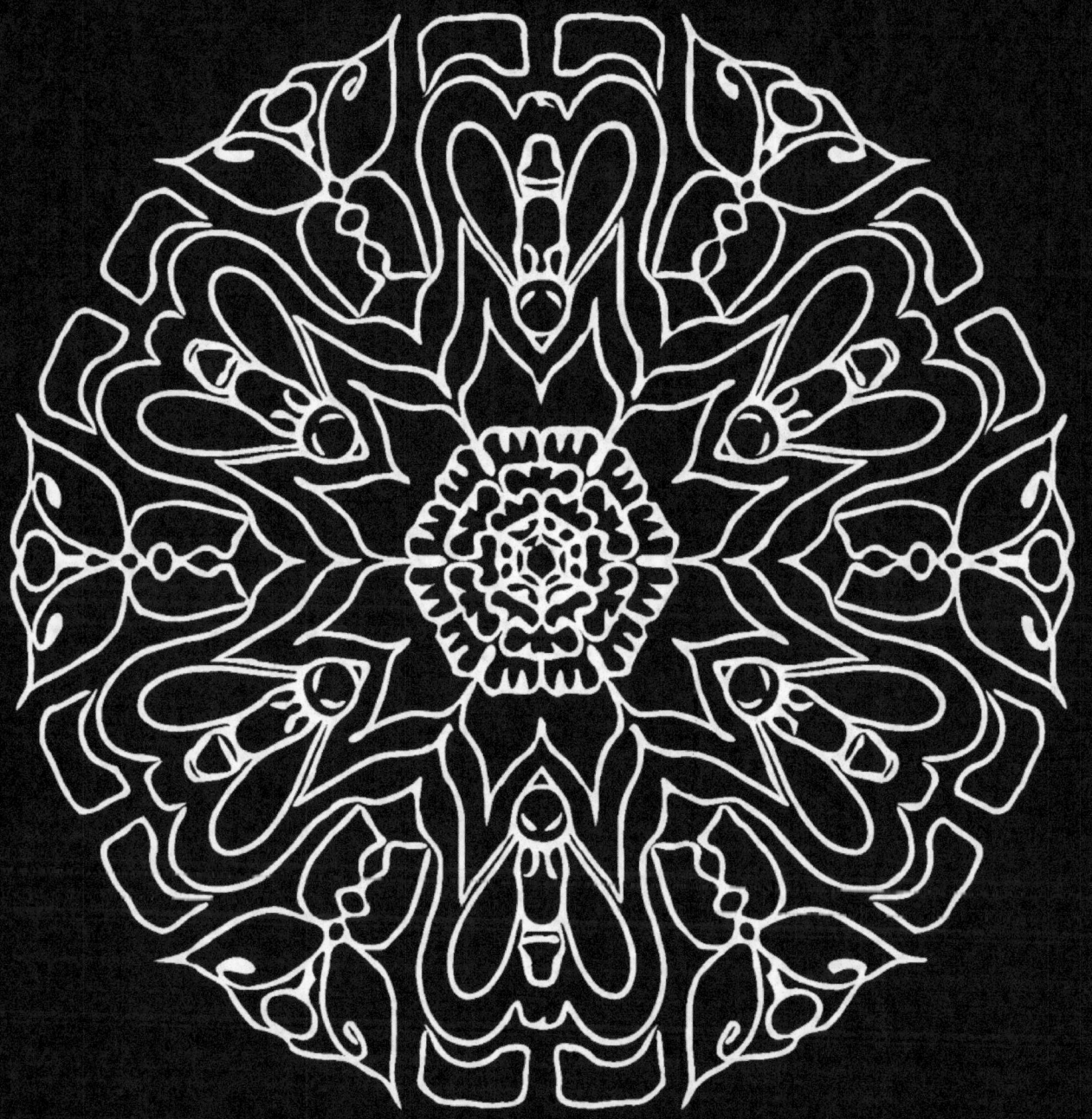

Join and Share your colored pages in the social media groups

Coloring City

&

Coloring with CherylColors

#CherylColorsArt

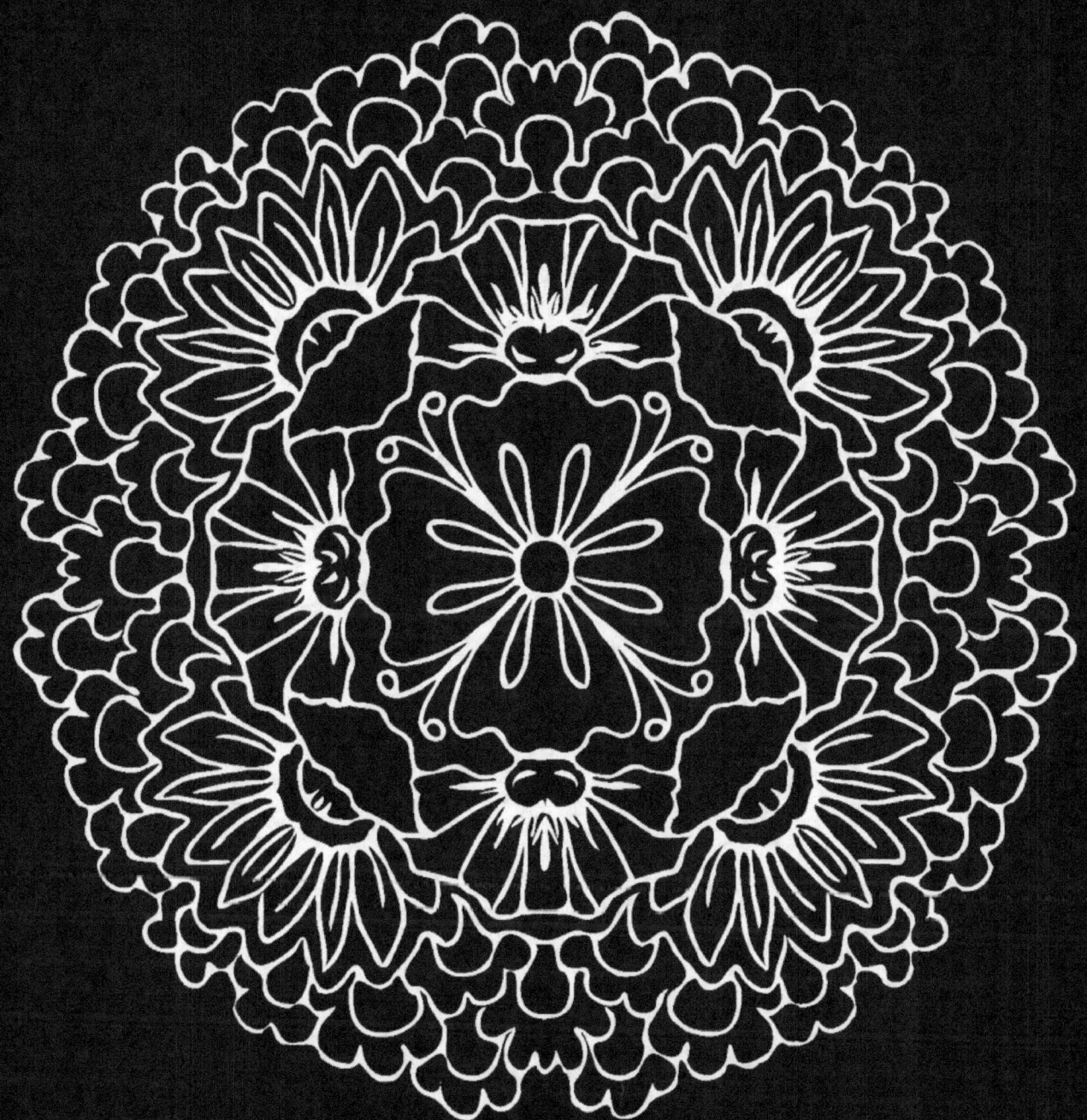

Join and Share your colored pages in the social media groups
Coloring City
&
Coloring with CherylColors

#CherylColorsArt

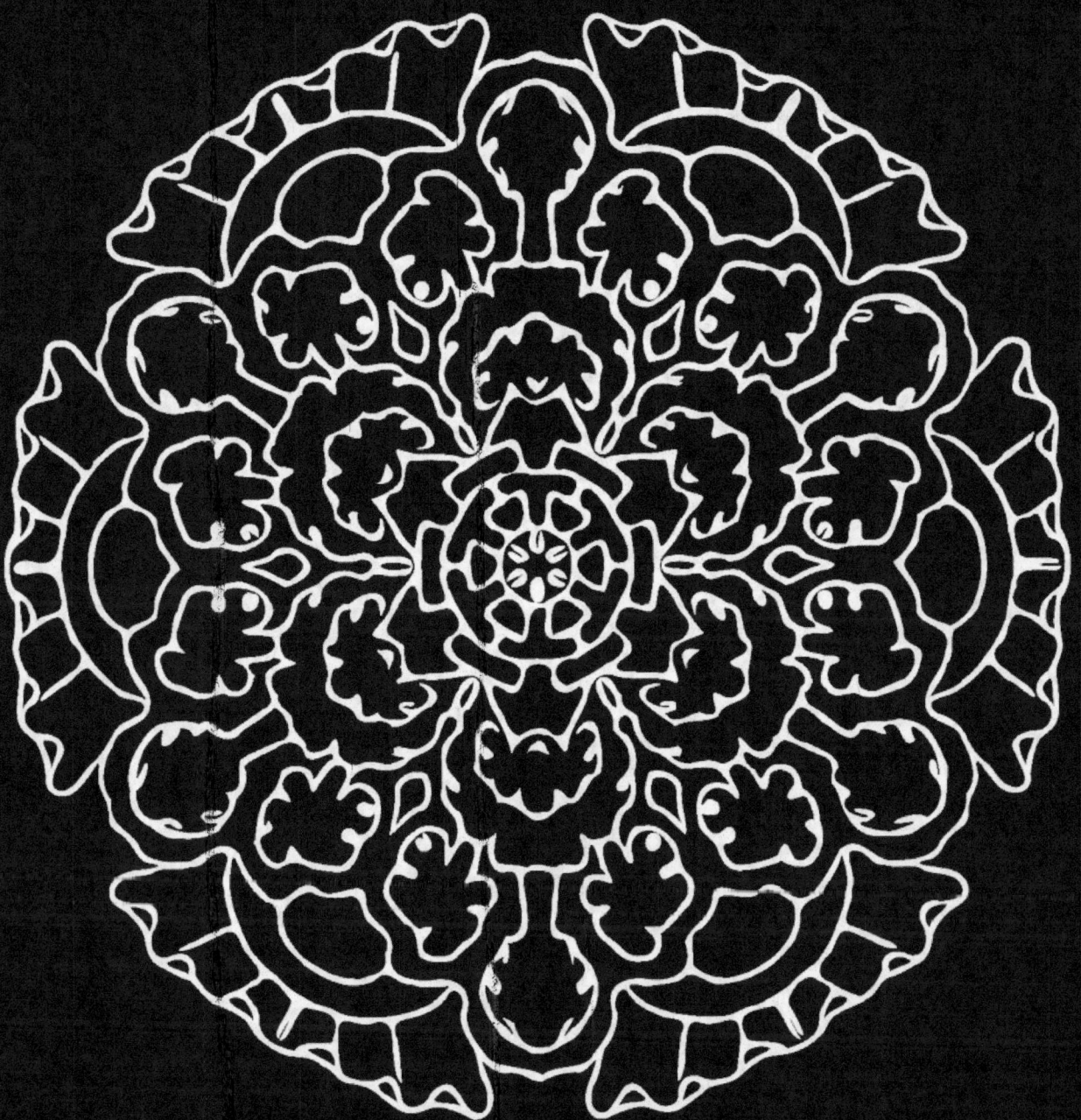

Join and Share your colored pages in the social media groups

Coloring City

&

Coloring with CherylColors

#CherylColorsArt

Collector Book Check List

Doodle Fun Mandala Coloring Books By Cheryl Colors

() Volume 1
() Volume 2
() Volume 3
() Volume 4
() Volume 5
() Volume 6
() Volume 7

Mandala Fun Adult Coloring Books By Cheryl Colors

() Volume 1
() Volume 2
() Volume 3
() Volume 4
() Volume 5

Midnight Mandala Fun Adult Coloring Books By Cheryl Colors

() Volume 1
() Volume 2
() Volume 3
() Volume 4

Midnight Madness Coloring Books By Cheryl Colors

() Volume 1
() Volume 2
() Volume 3
() Volume 4
() Volume 5
() Volume 6
() Volume 7

Remove this blotter page and use it behind your coloring pages to prevent ink bleed through from markers and gel pens.

Blotter

Remove this blotter page and use it behind your coloring pages to prevent ink bleed through from markers and gel pens.

Blotter

www.ingramcontent.com/pod-product-compliance
Lightning Source LLC
Chambersburg PA
CBHW081436220526
45466CB00008B/2408